BLOSSOM BUDDIES

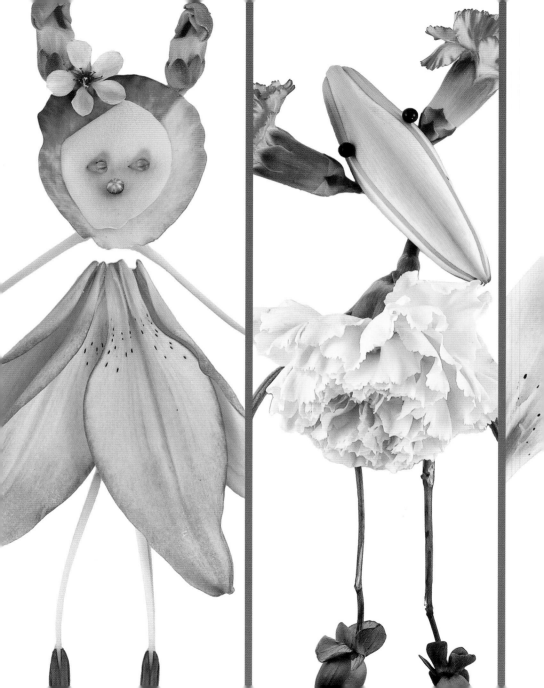

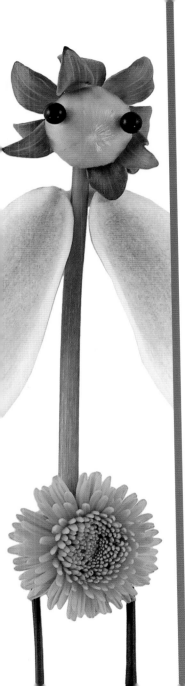

BLOSSOM BUDDIES

a garden variety

By Elsa Mora

teNeues

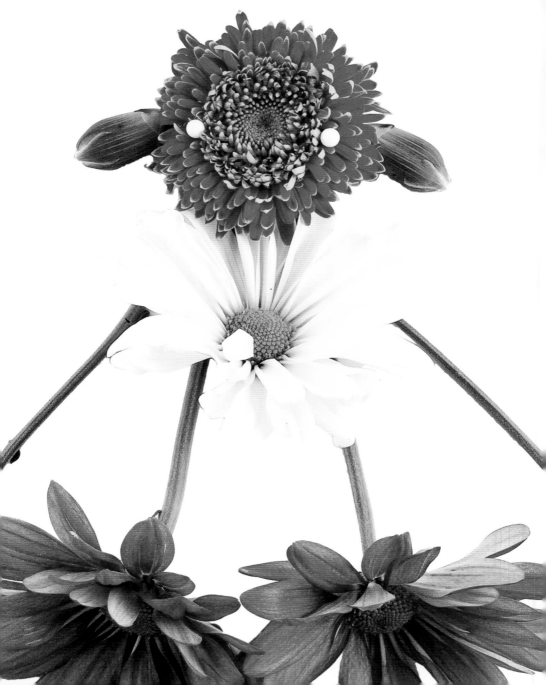

SOMETIMES LIFE GOES SO FAST, we have so many things to do and so much to take care of that we simply forget to stop and smell the flowers. On one of those typical days when I was really busy chasing my three-year-old son around, he opened the back door and ran straight into our garden. I decided to slow down at that point and just observe him. Children have an amazing sense of wonder that is contagious when we pay attention to it. He was fascinated with the little flowers, the grass, the leaves and everything around him so I just let him enjoy our garden and I was happy to join him in the game. Later on that afternoon I still felt like a little kid myself so I went out with a basket and collected some natural elements like petals, branches, leaves…and started composing silly characters with them in my studio. Since they were so fragile I decided to take some photos so I could look at them later, and that was the beginning of the series of flower characters that I am so excited to share with you in this book. I realized that playing with natural elements in a creative way was a wonderful hobby that I am sure you will enjoy if you try it yourself. I hope that the pages of this book bring a smile to your face and also make you think that it is important to slow down sometimes and enjoy the simple things that life and nature have to offer us everyday.

Elsa Mora

MANCHMAL GEHT DAS LEBEN RASEND SCHNELL AN EINEM VORBEI, man hat Tausende von Dingen, die man erledigen und um die man sich kümmern muss, so dass wir oft einfach vergessen, innezuhalten und unsere Umgebung in uns aufzunehmen. An einem dieser üblich hektischen Tage war ich damit beschäftigt, meinen dreijährigen Sohn zu beaufsichtigen. Er öffnete die Tür und rannte direkt in unseren Garten. Ich beschloss, ihn einfach zu beobachten. Für Kinder sind Erforschungen der für sie neuen Dinge in ihrer Umgebung mit Magie verbunden, was ansteckend sein kann, wenn man aufmerksam ist. Er war fasziniert von den kleinen Blumen, dem Gras, den Blättern und allem, was um ihn herum war, so dass ich gar nichts machte und ihm einfach Gelegenheit gab, sich an unserem Garten zu erfreuen. Und mir machte es Spaß, diese Freude mit ihm zu teilen. Später am Nachmittag fühlte ich mich selbst immer noch wie ein kleines Kind. Ich ging also mit einem Korb in den Garten und sammelte Dinge wie Blütenblätter, Zweige und Blätter und ich fing an, in meinem Studio ulkige Blumenmenschen zu entwerfen. Da sie sehr fragil waren, fotografierte ich einige, damit ich sie später betrachten konnte. So nahm diese Blumenm schenserie, die ich Ihnen in diesem Buch vorstellen möchte, ihren Afang. Mir wurde klar, dass der kreative Umgang mit Dingen aus der Natur ein wunderschönes Hobby ist. Ich bin sicher, dass es Ihnen auch gefallen würde, wenn Sie es erst einmal ausprobieren. Ich hoffe, dass das Durchblättern dieses Buches ein Lächeln auf Ihr Gesicht zaubert und Sie dazu veranlasst, darüber nachzudenken, dass es wichtig ist, manchmal innezuhalten und sich der einfachen Dinge zu erfreuen, die das Leben und die Natur uns jeden Tag zu bieten haben.

Elsa Mora

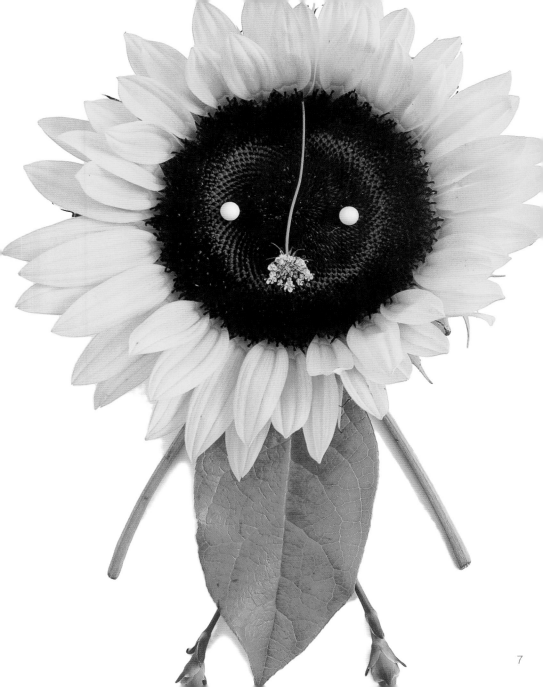

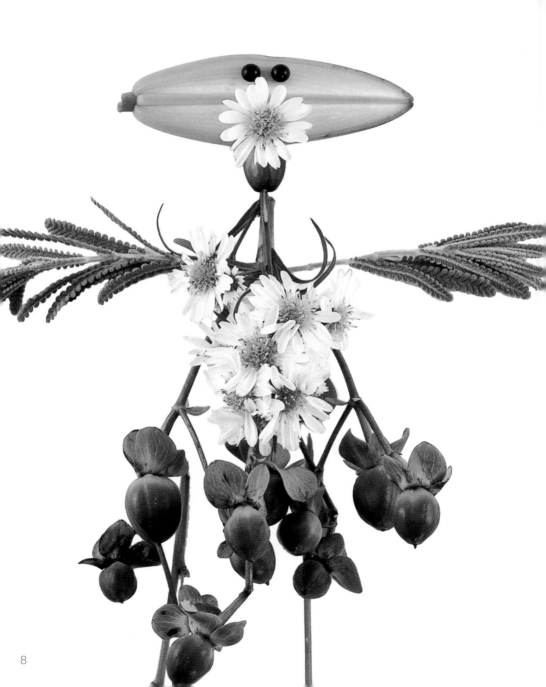

PARFOIS TOUT VA SI VITE DANS LA VIE, nous avons tellement à faire et tant de choses dont nous devons nous occuper que nous oublions tout simplement de nous arrêter pour sentir les fleurs. Une de ces journées habituelles, lorsque j'étais réellement occupées à courir après mon fils de trois ans, il ouvrit la porte de derrière et courut tout droit dans le jardin. C'est là que j'ai décidé de laisser faire et de me contenter de l'observer. C'est extraordinaire comme les enfants savent s'émerveiller et c'est contagieux si nous y prêtons attention. Il était fasciné par les petites fleurs, l'herbe, les feuilles et tout ce qui l'entourait et je l'ai laissé profiter de notre jardin en me sentant heureuse de participer à son jeu. Plus tard dans l'après-midi, je me sentais encore moi-même comme une petite fille et je suis sortie avec un panier pour ramasser des éléments naturels comme des pétales, des branches et des feuilles et j'ai commencé à en faire des personnages drôles dans mon studio. Du fait qu'ils étaient tellement fragiles, j'ai décidé de prendre quelques photos pour pouvoir les regarder plus tard et ce fut le début d'une série de personnages fleurs que je suis tellement excitée de partager avec vous dans ce livre. J'ai réalisé que le fait de jouer avec des éléments naturels d'une façon créative était un hobby merveilleux et je suis sûre que vous allez aimer si vous essayez vous-même. J'espère que les pages de ce livre vous feront sourire en vous rapelant qu'il est iportant parfois de prendre le temps de profiter des plaisirs simples que la vie et la nature nous offrent chaque jour.

Elsa Mora

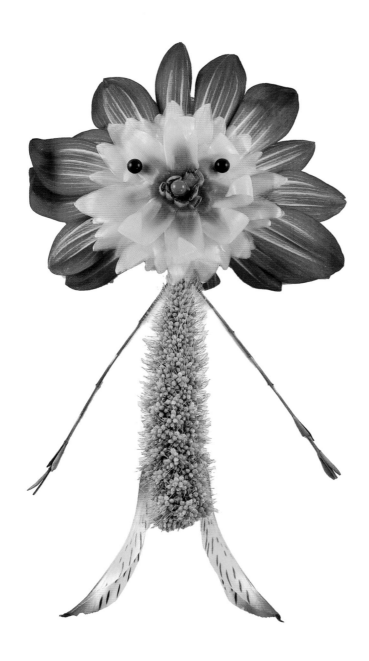

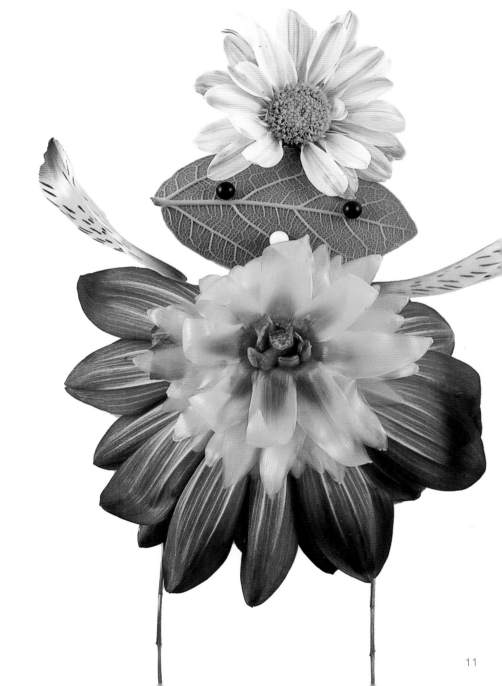

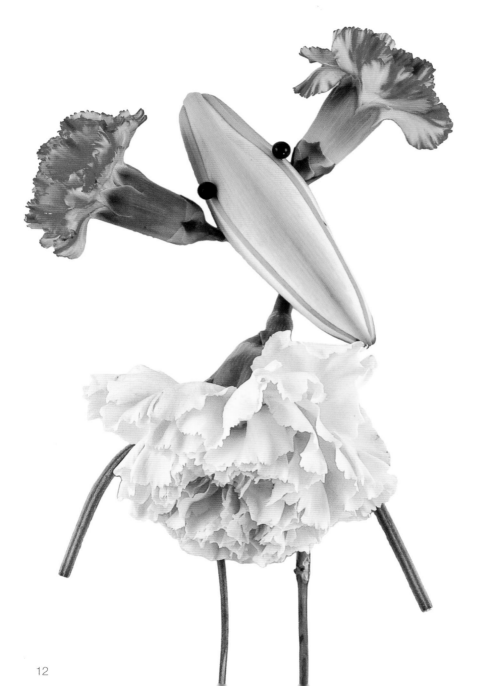

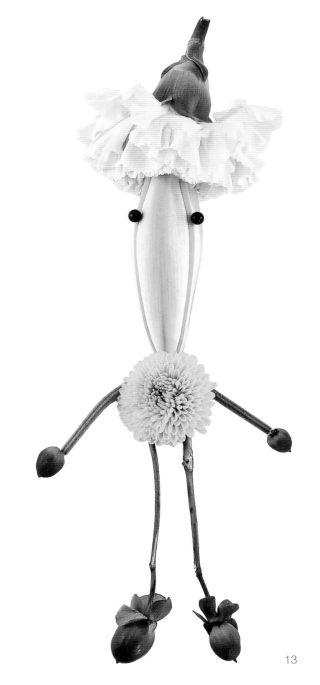

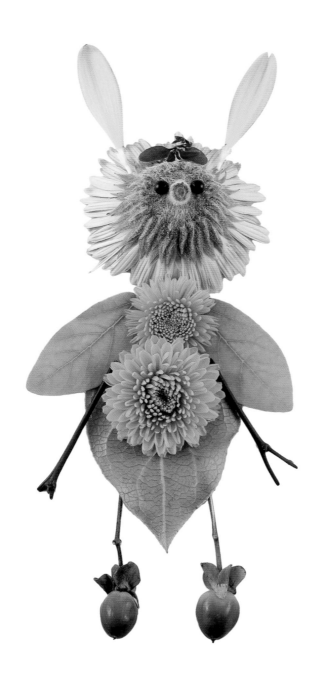

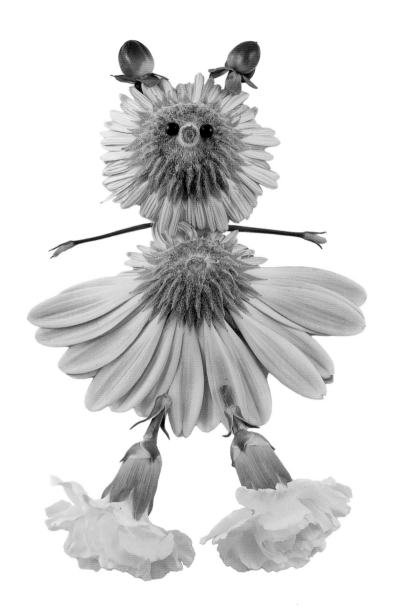

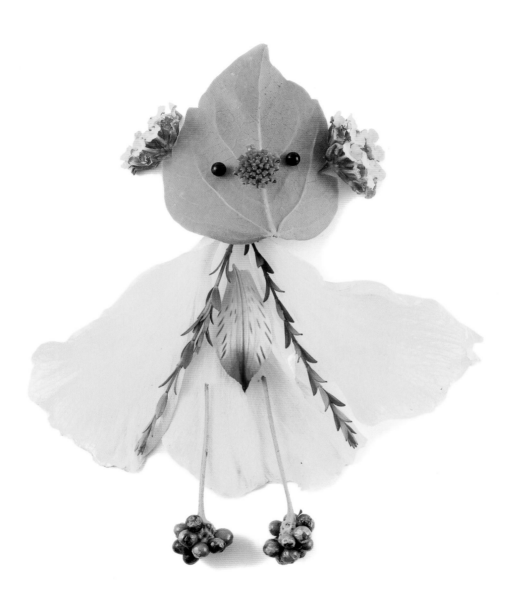

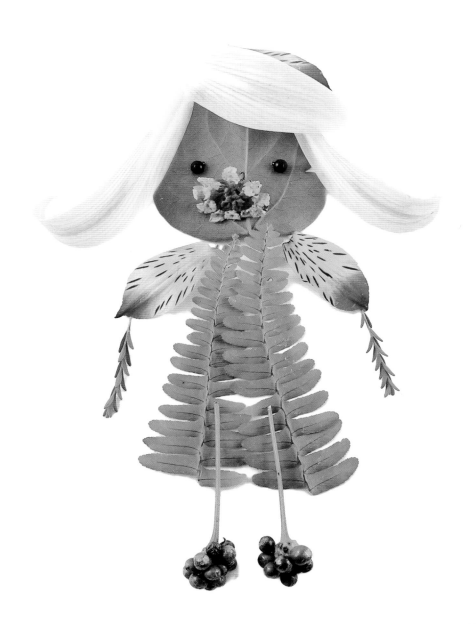

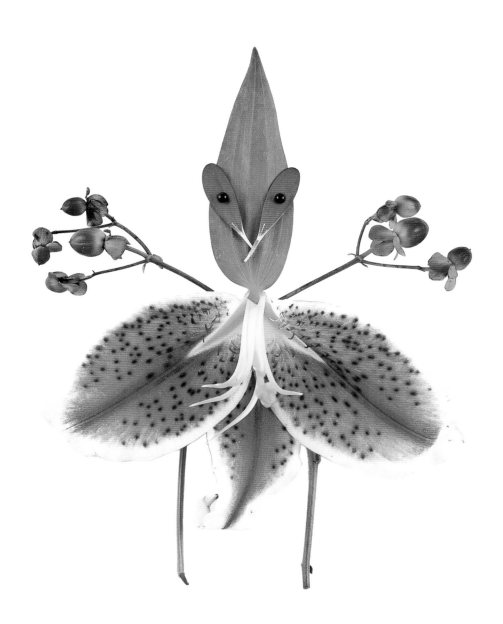

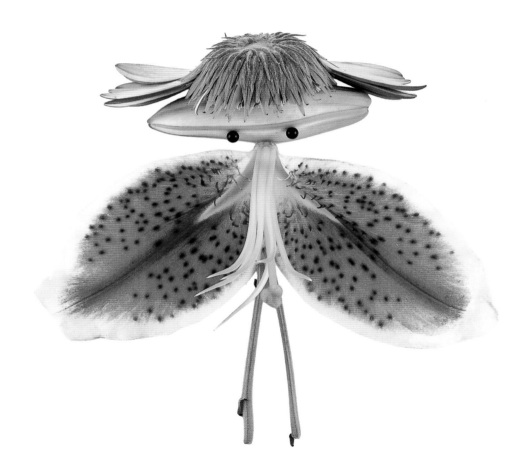

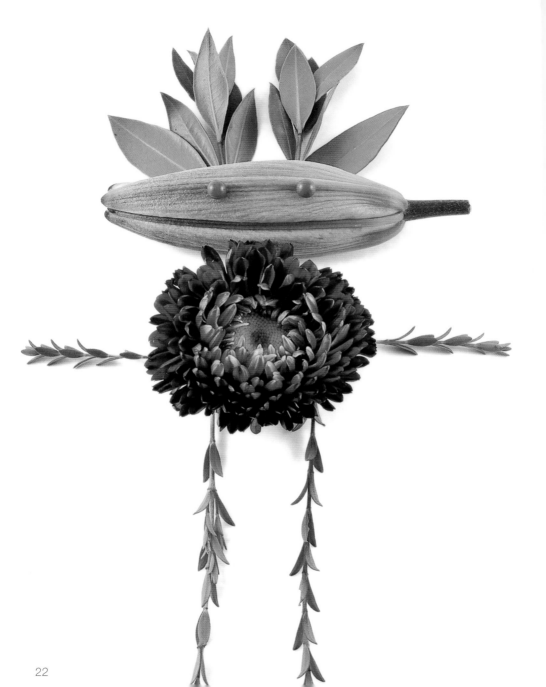

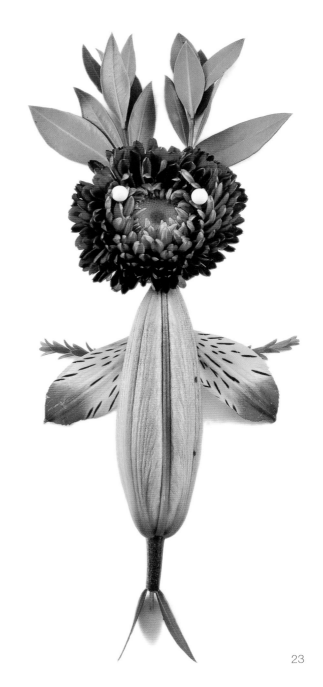

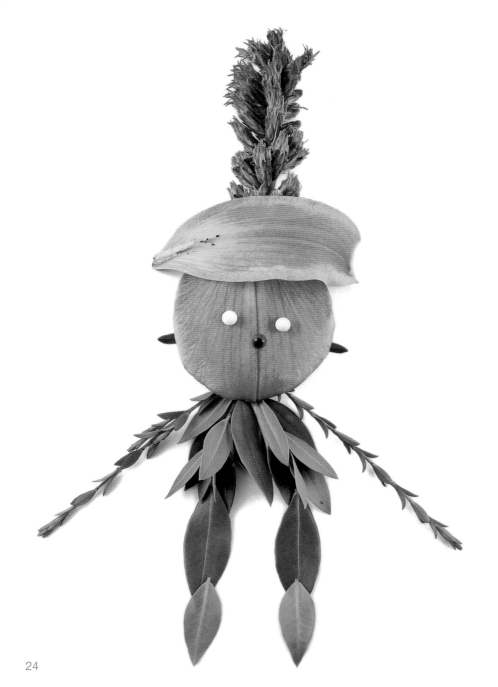

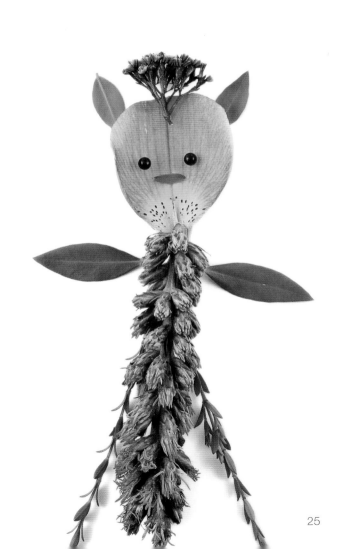

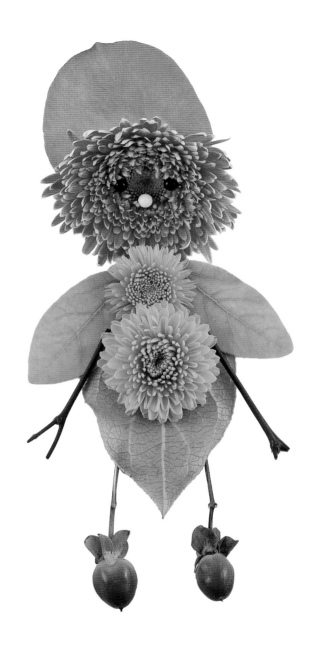

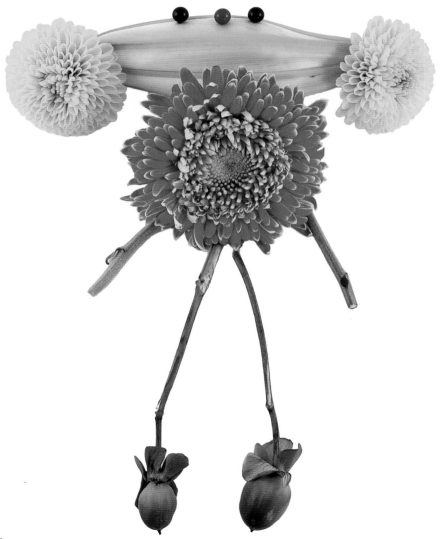

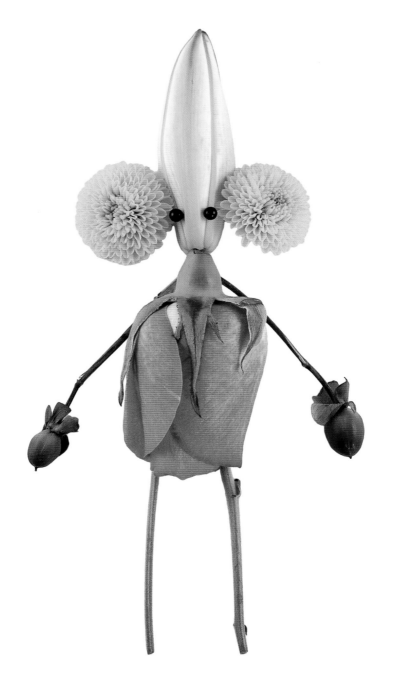

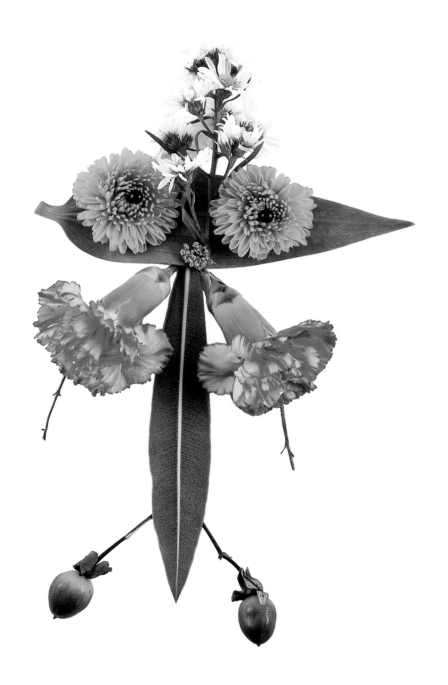

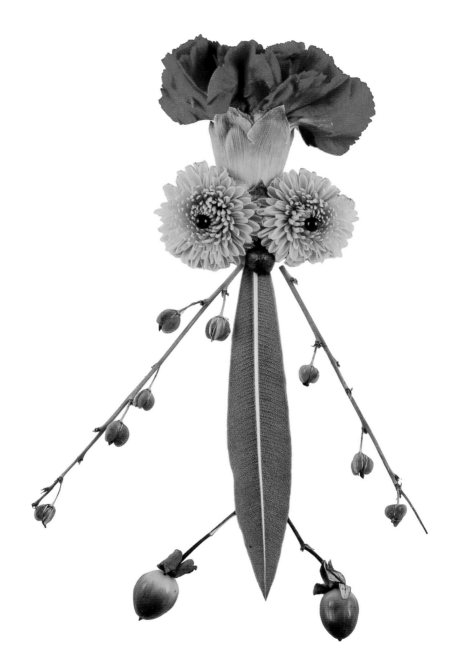

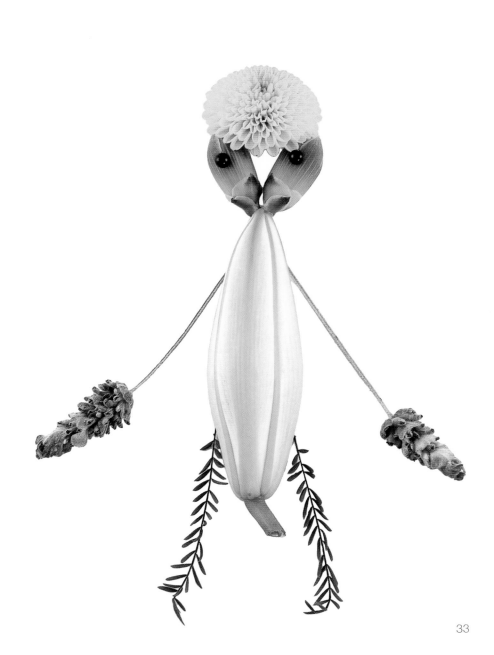

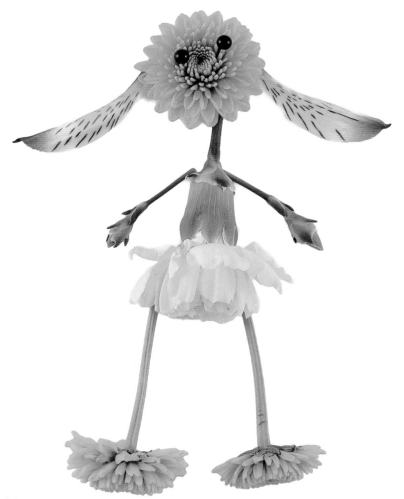

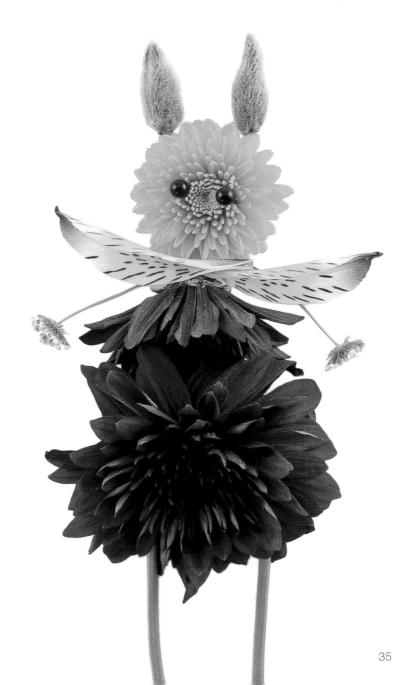

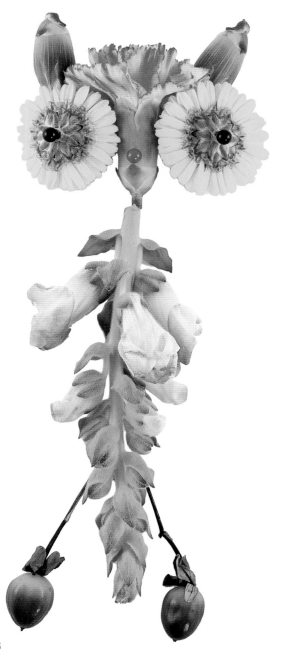

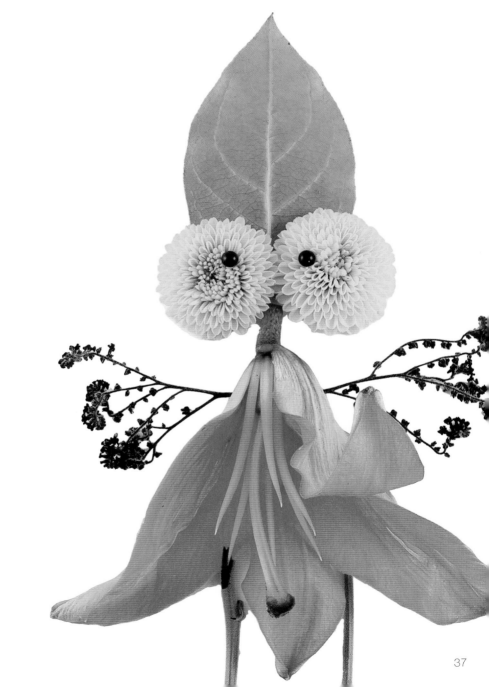

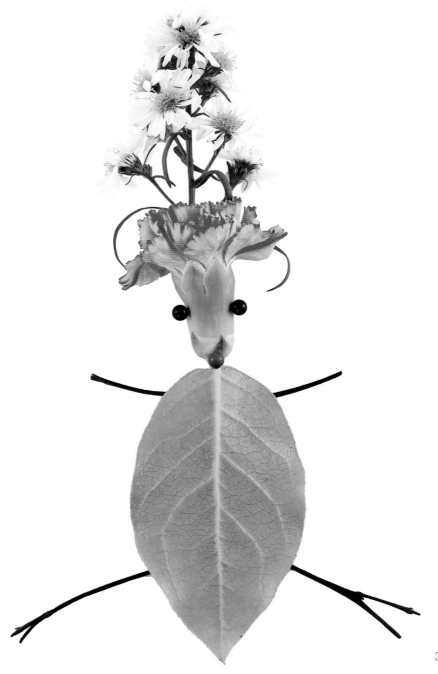

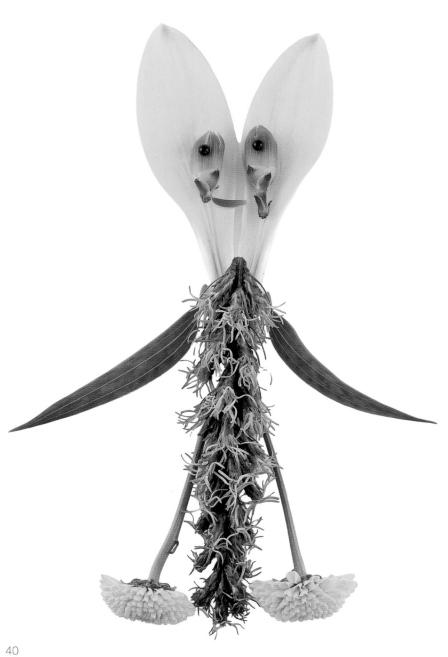

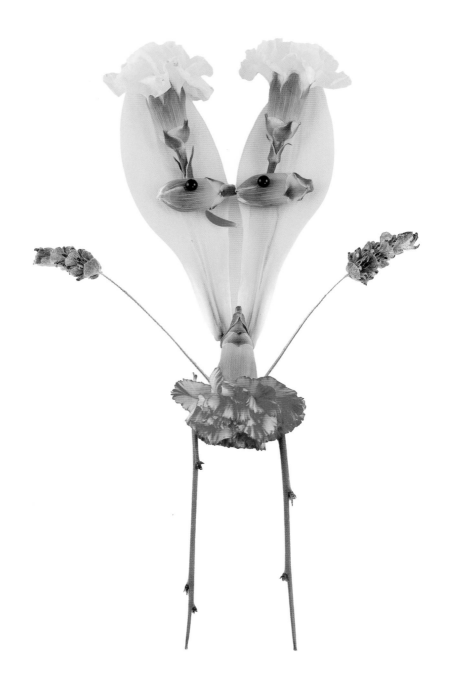

41

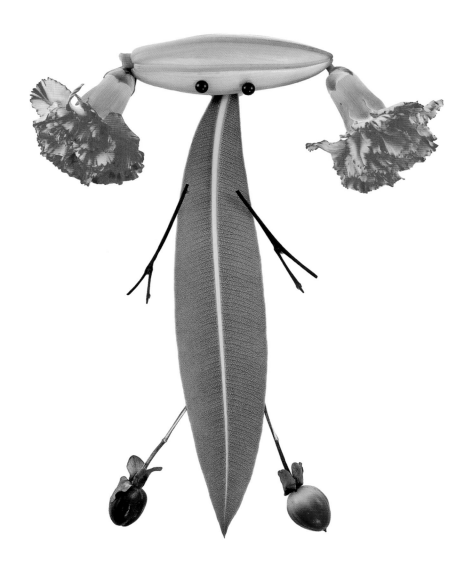

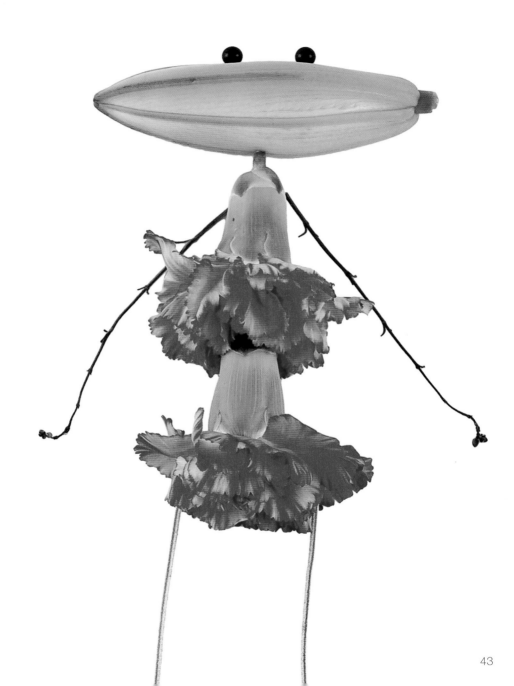

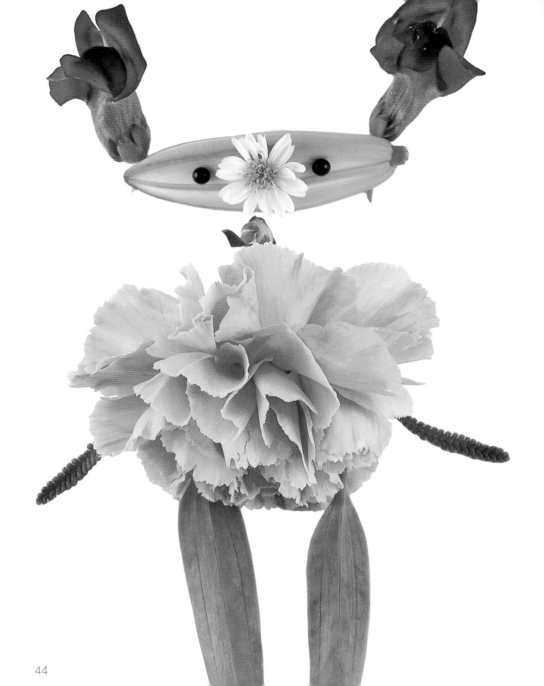

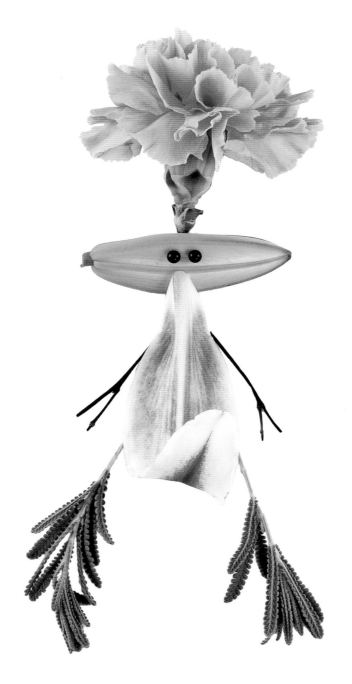

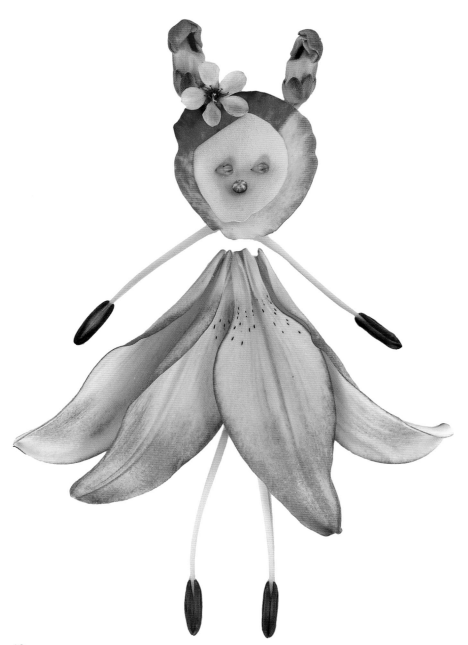

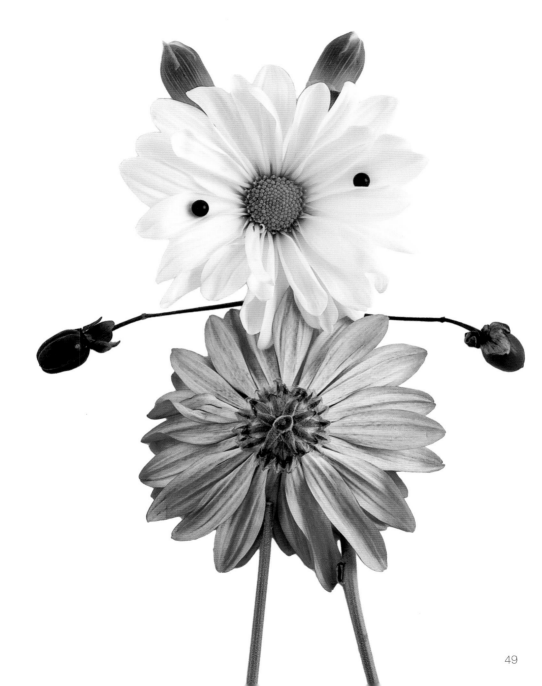

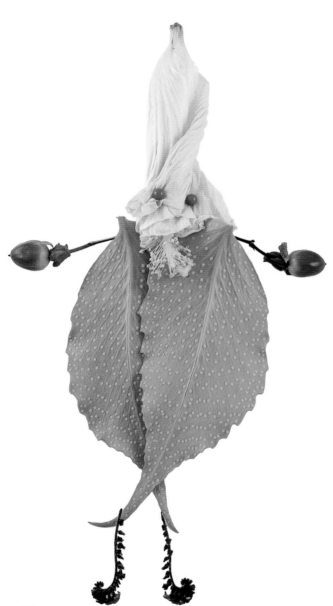

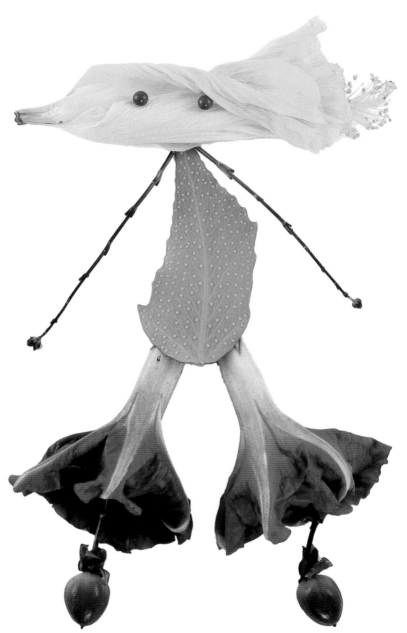

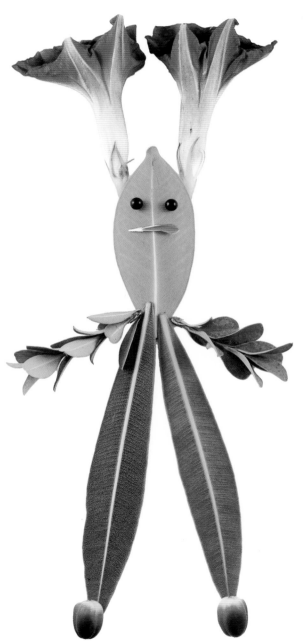

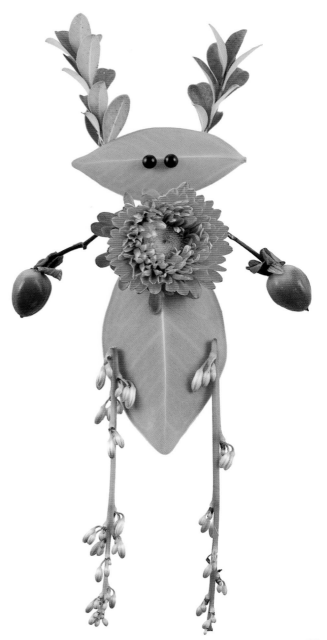

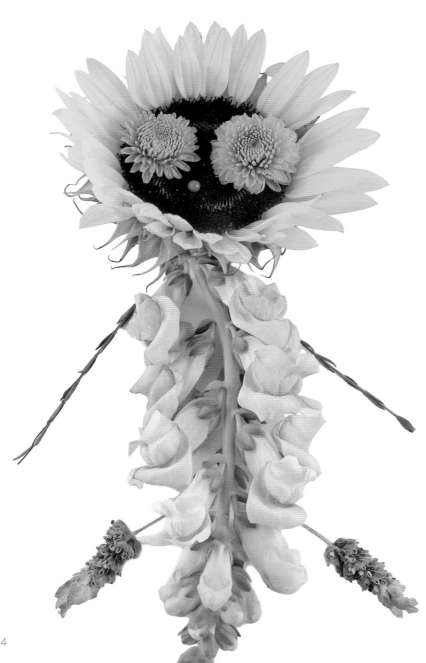

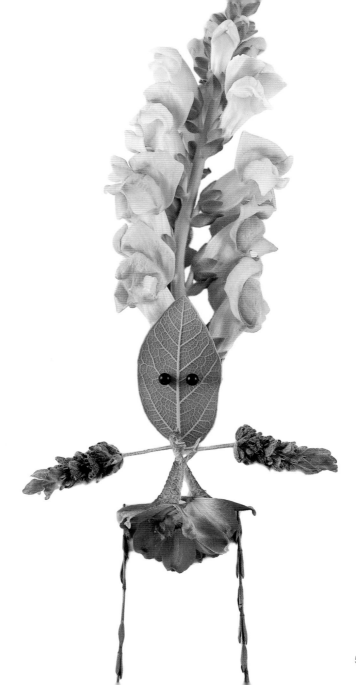

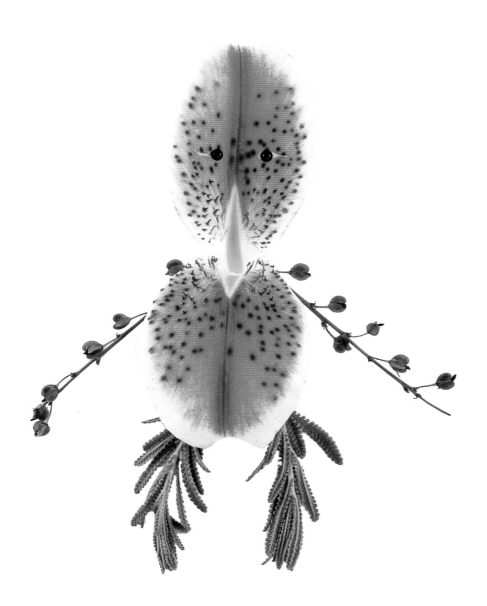

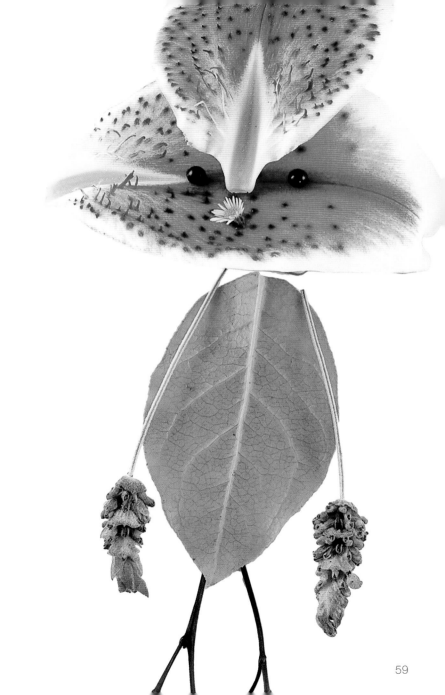

59

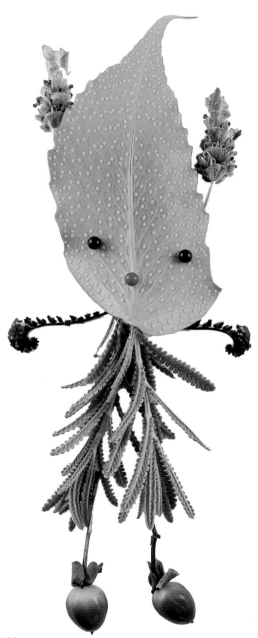

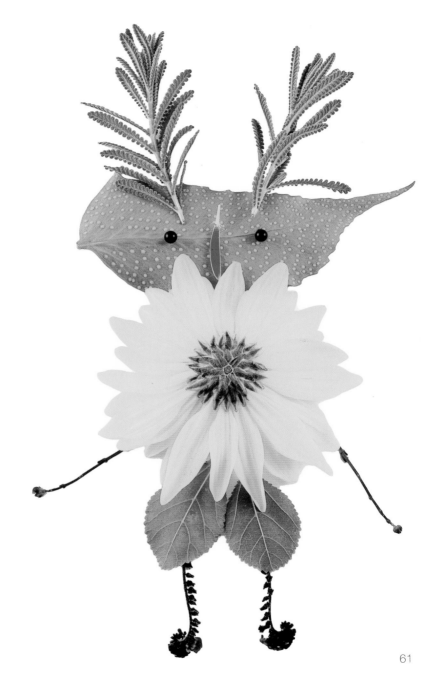

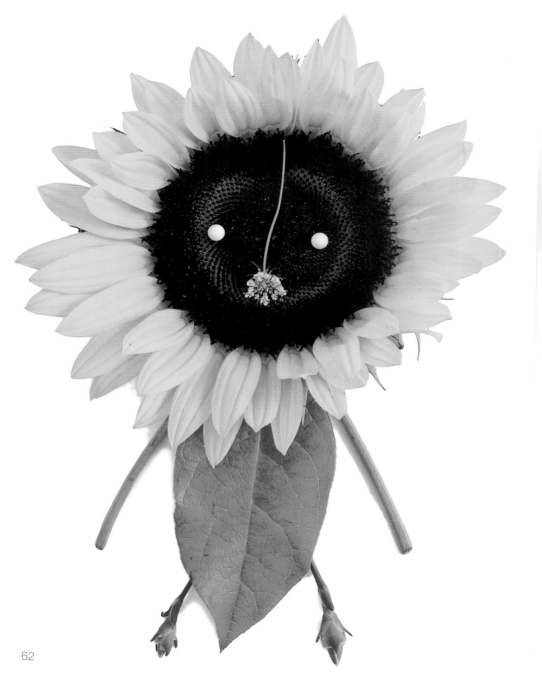

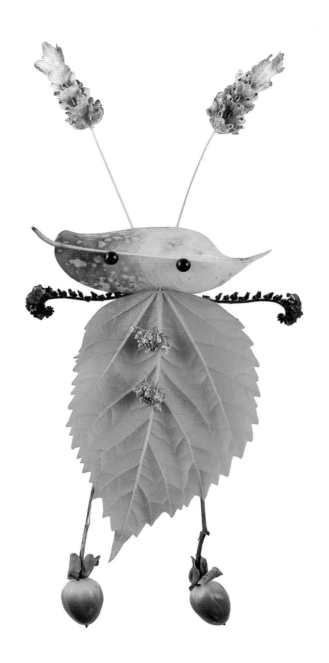

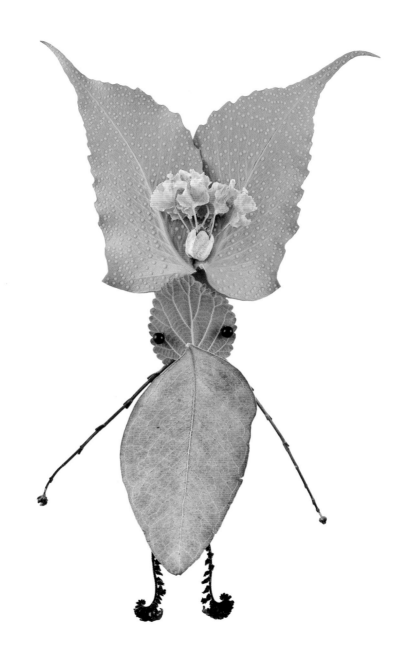

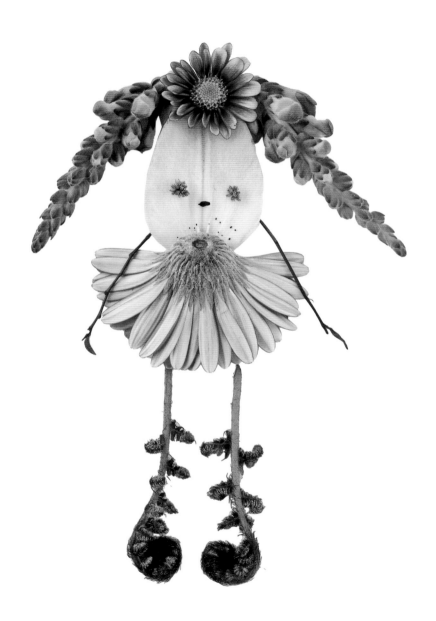

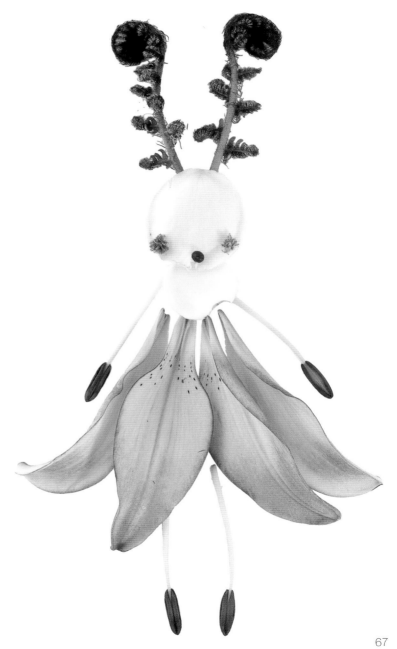

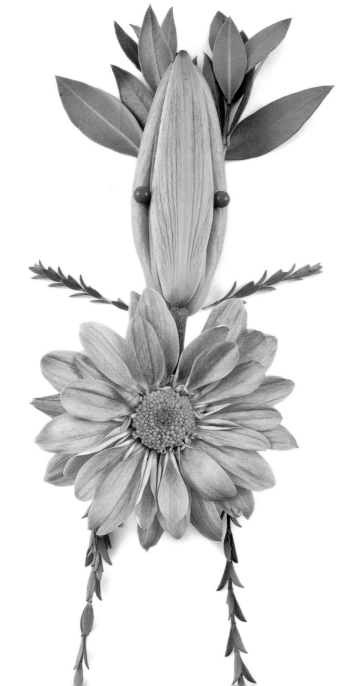

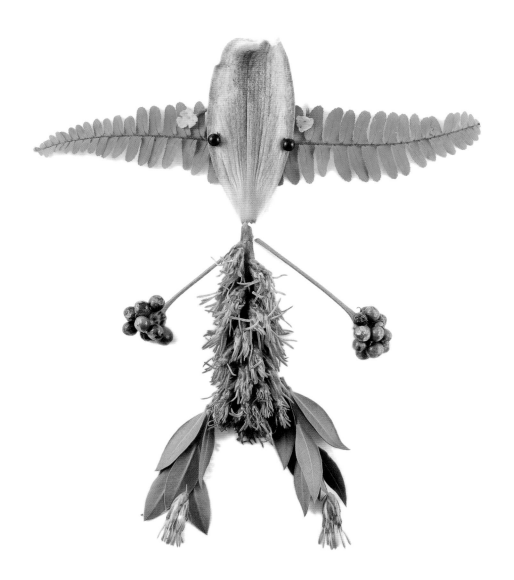

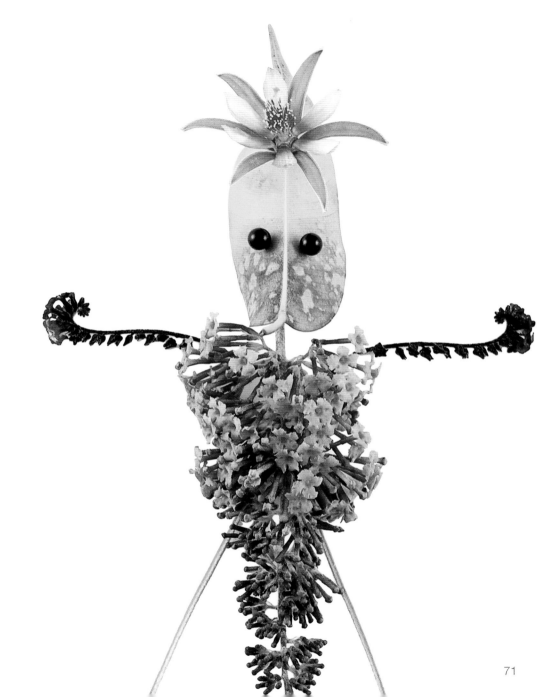

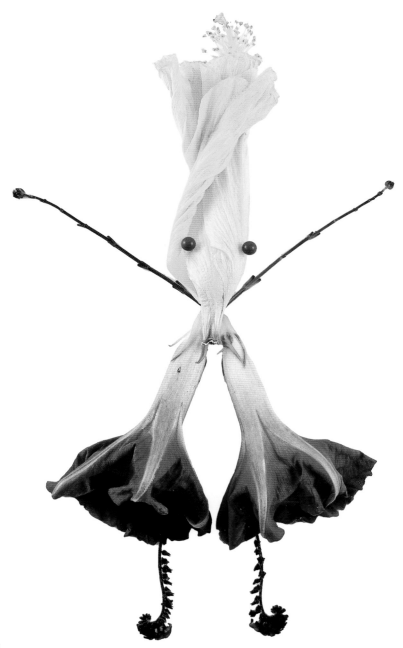

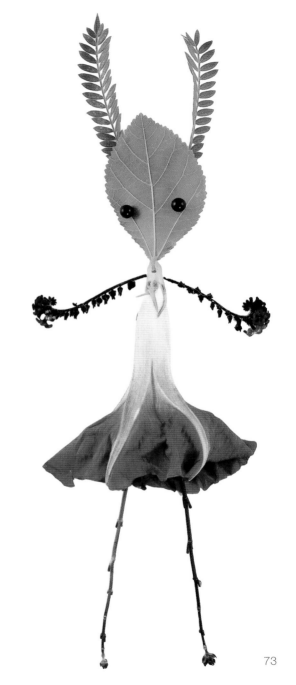

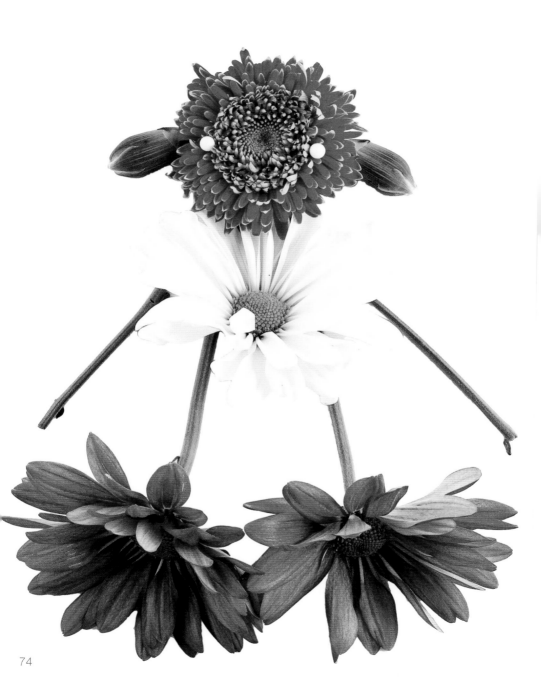

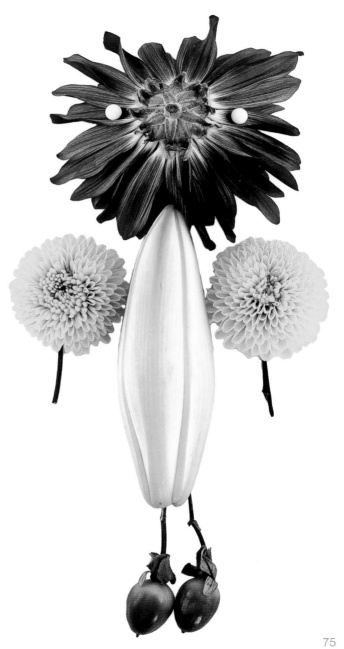

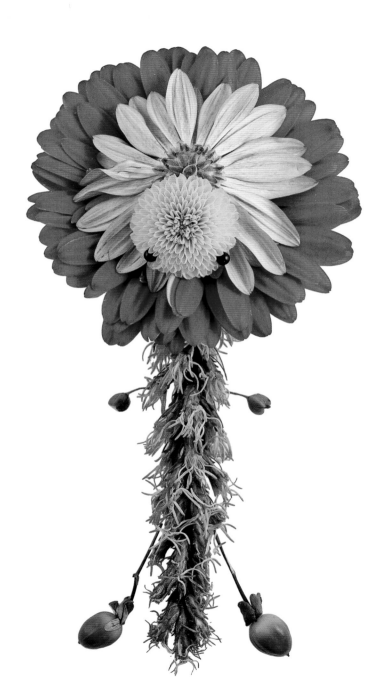

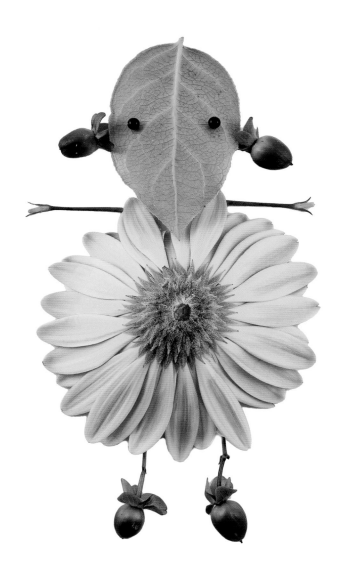

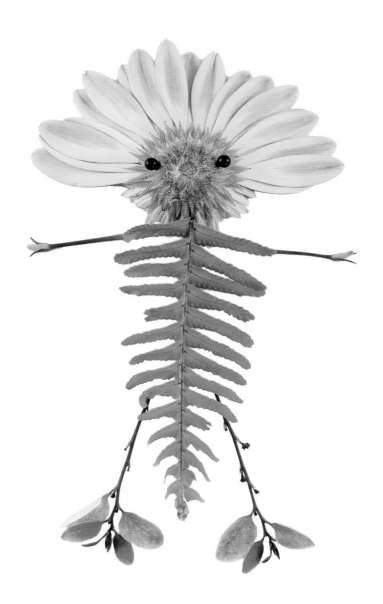

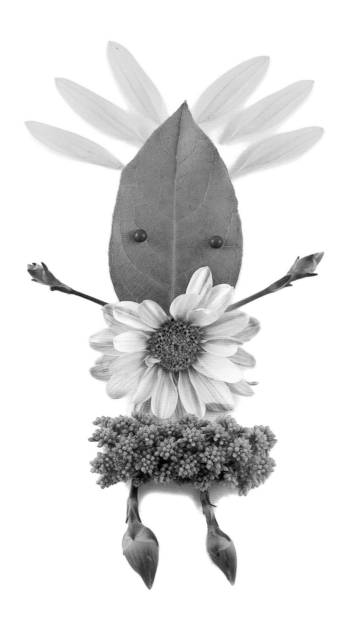

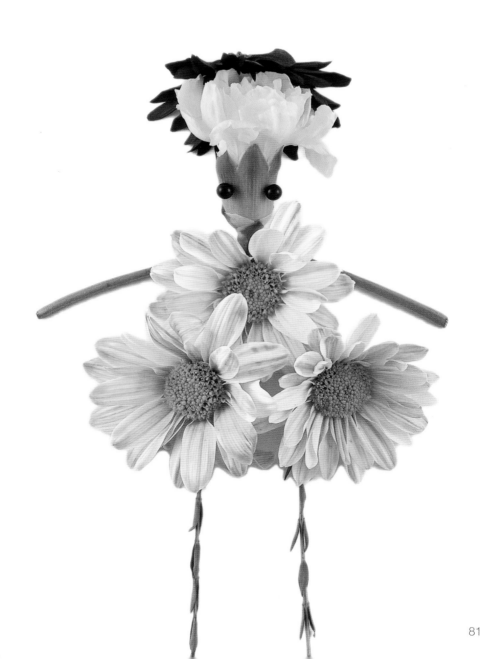

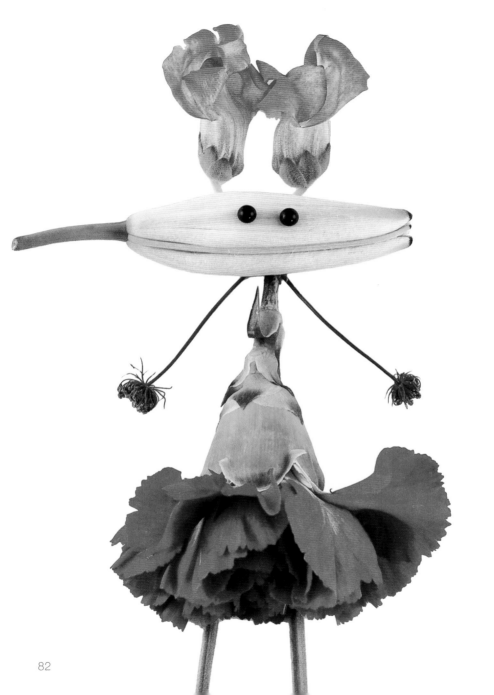

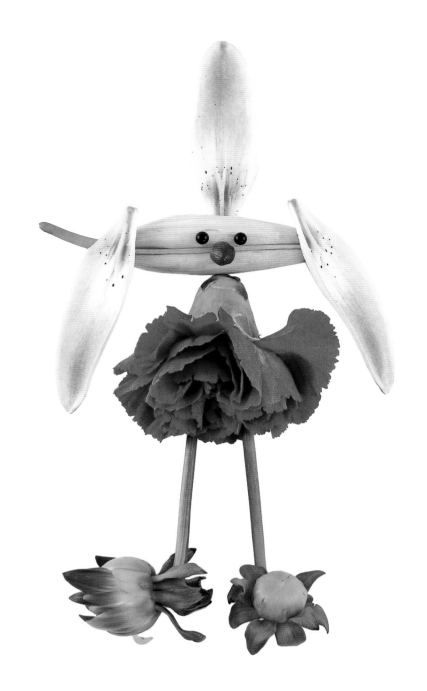

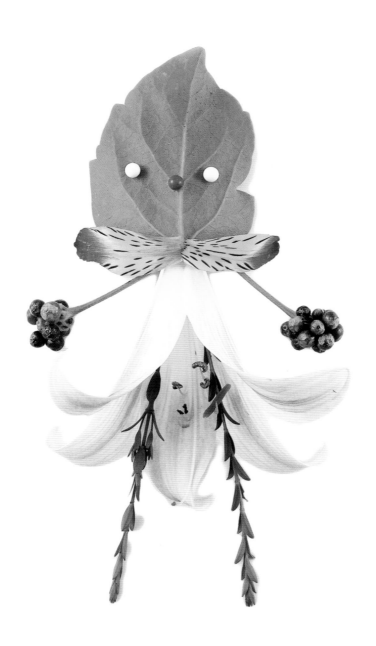

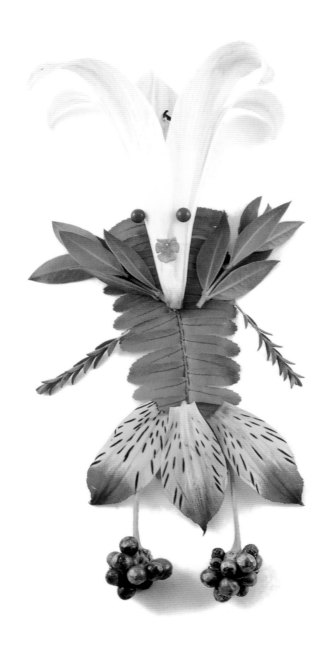

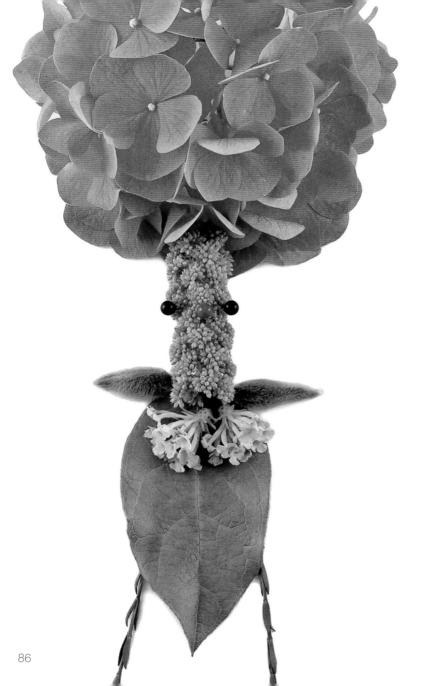

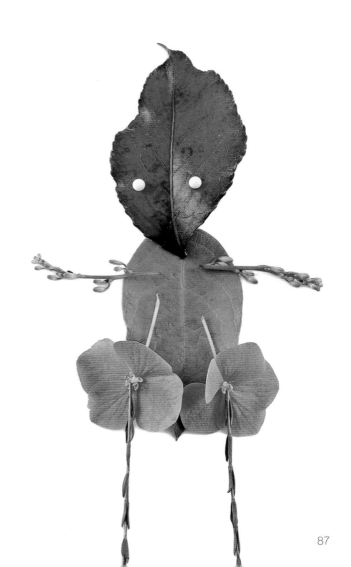

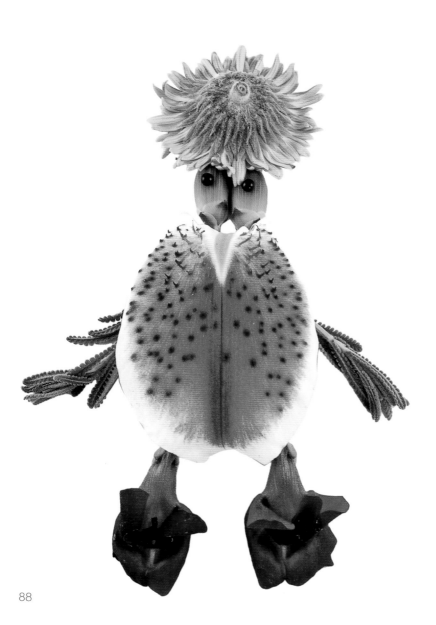

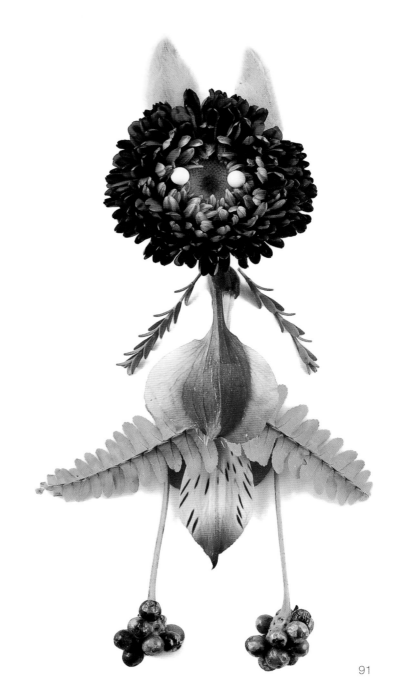

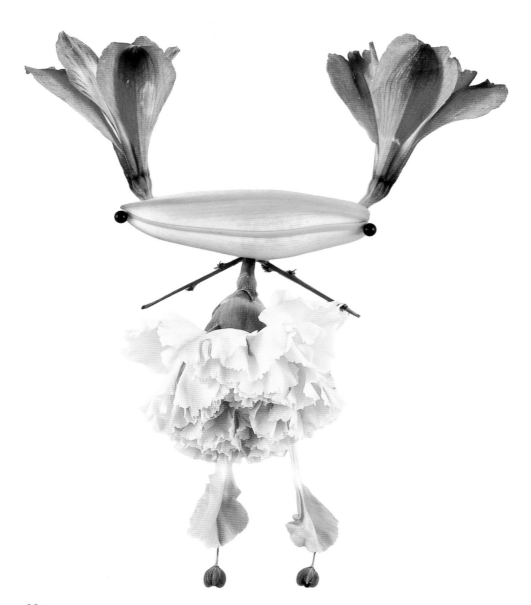

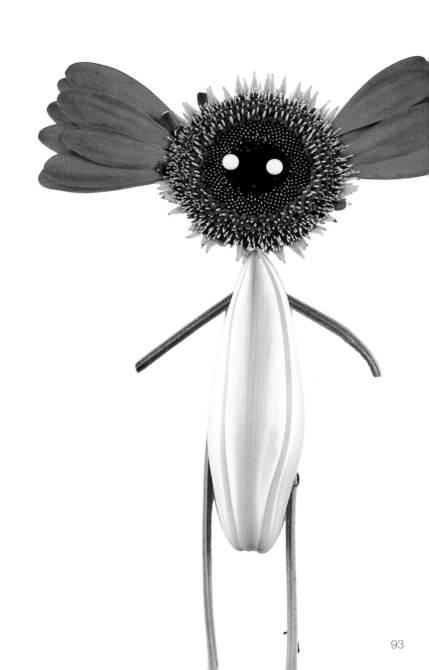

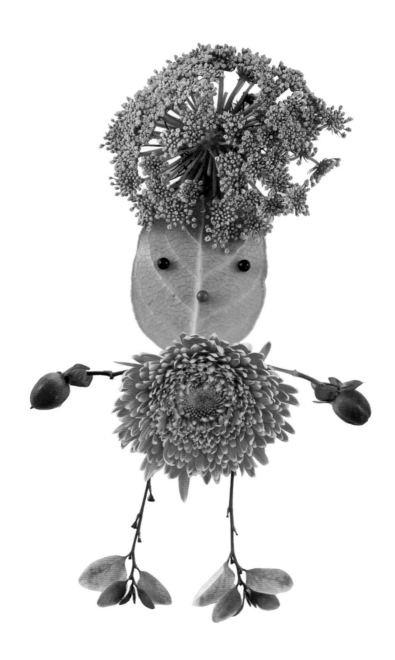

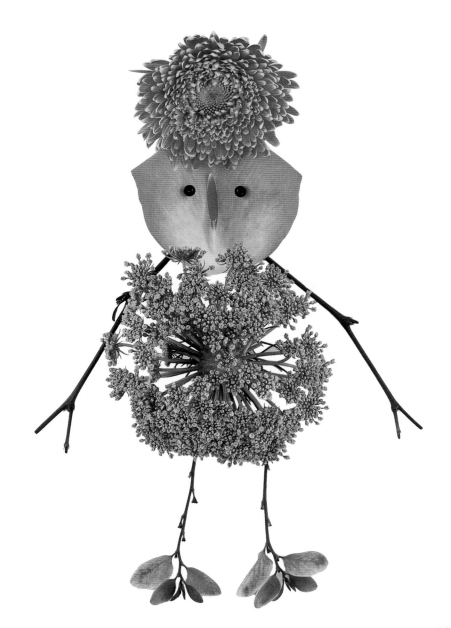

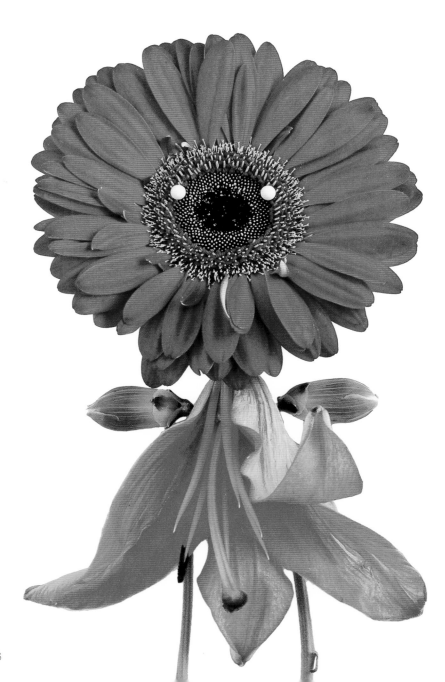

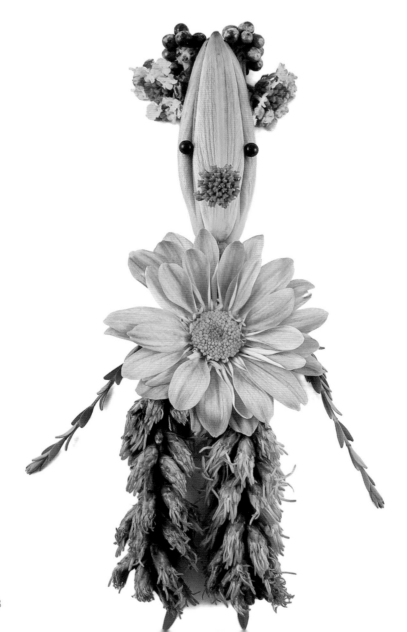

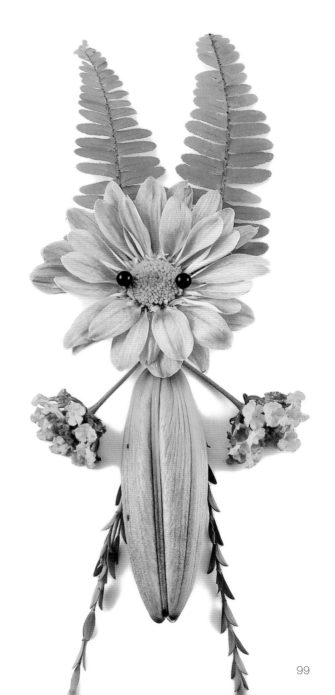

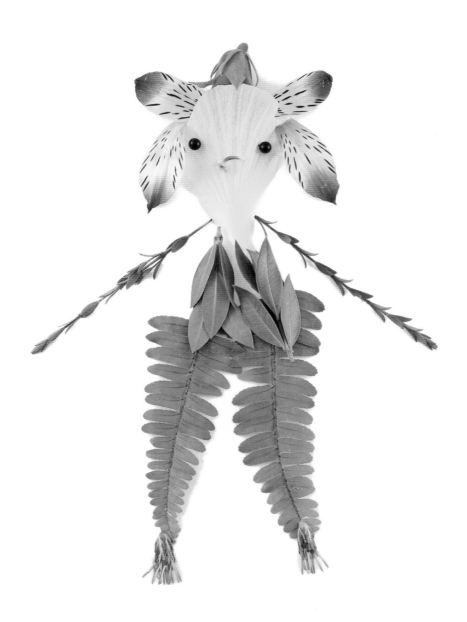

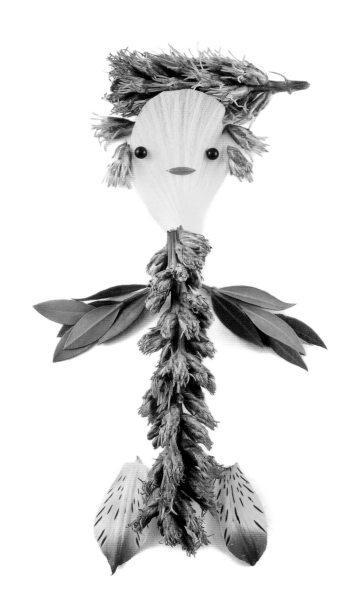

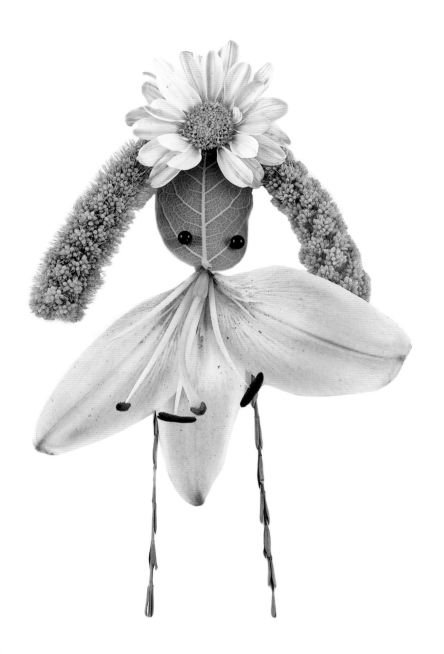

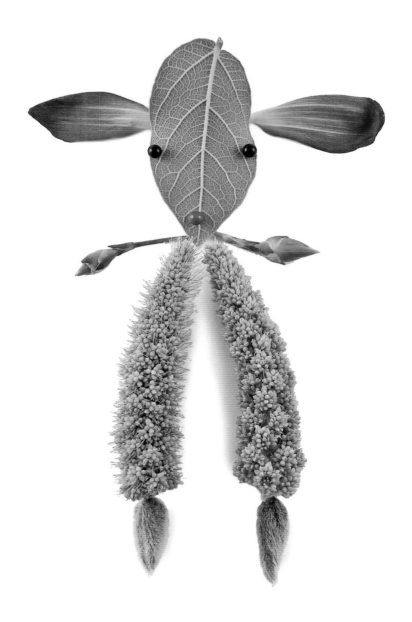

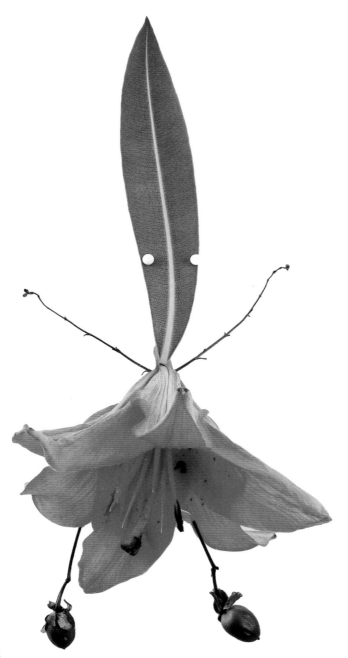

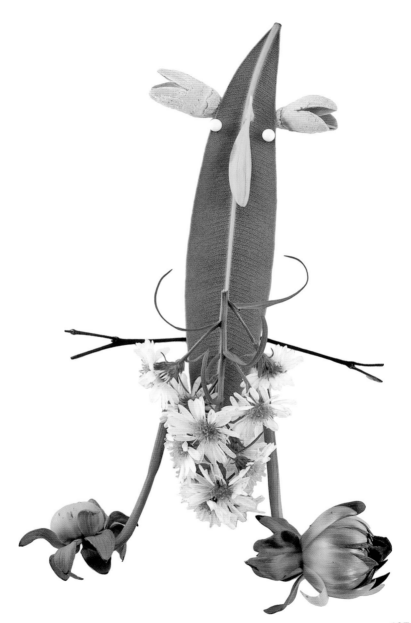

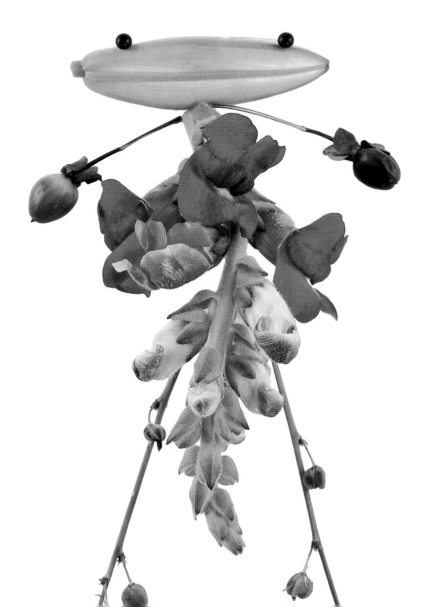

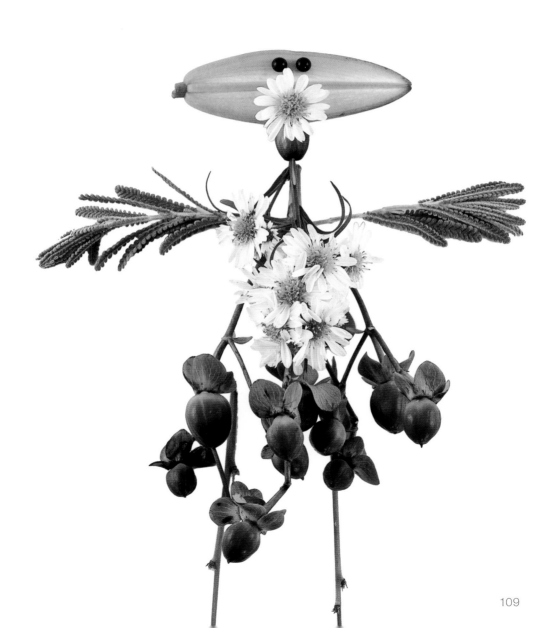

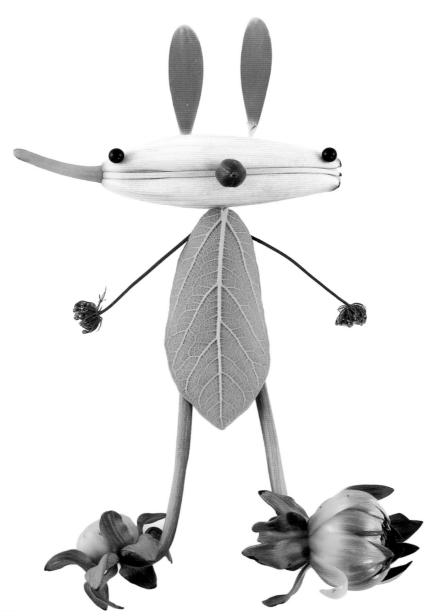

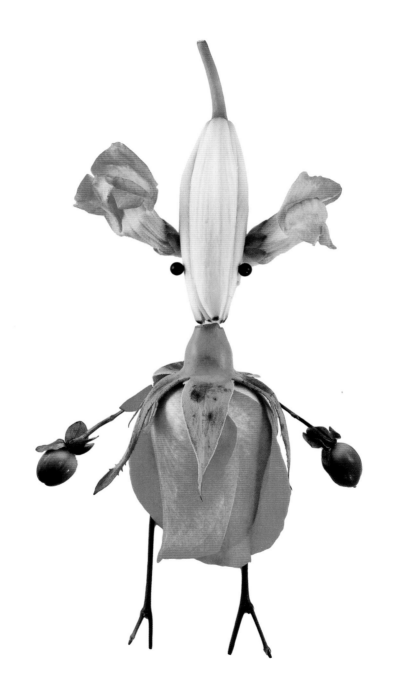

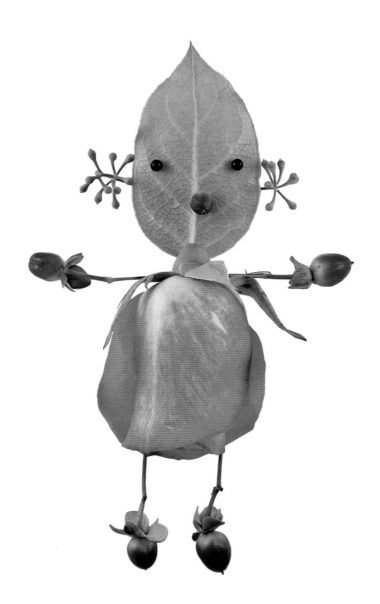

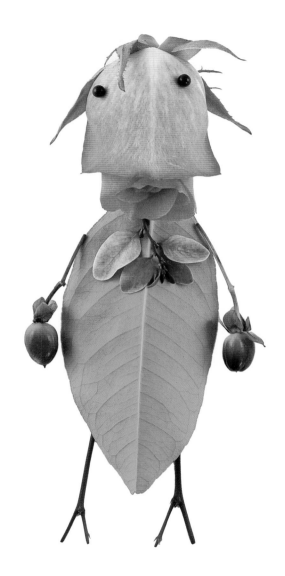

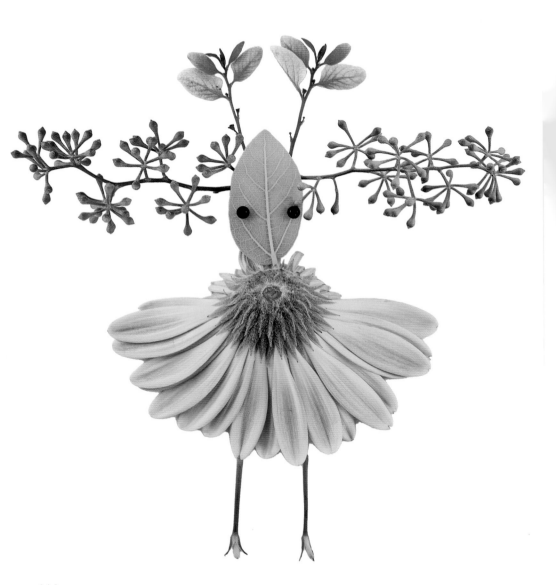

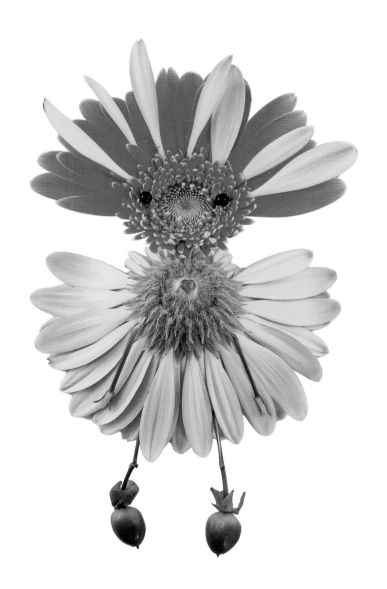

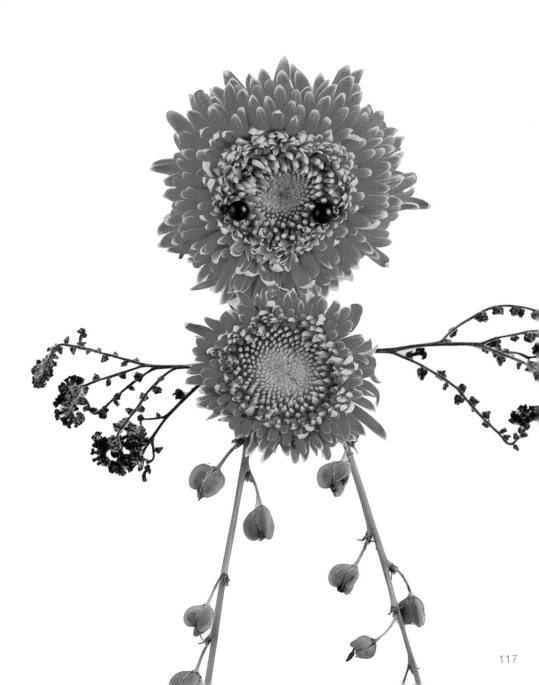

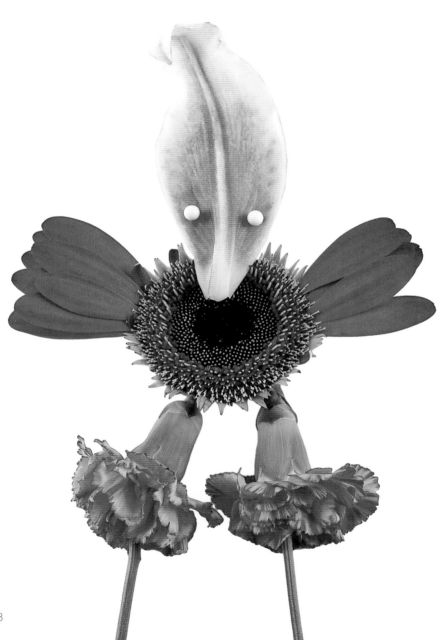

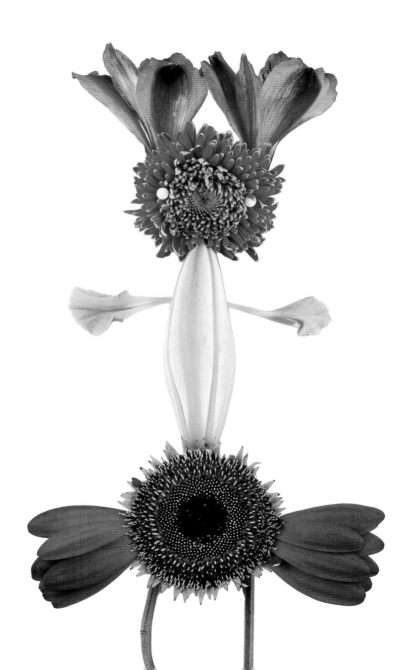

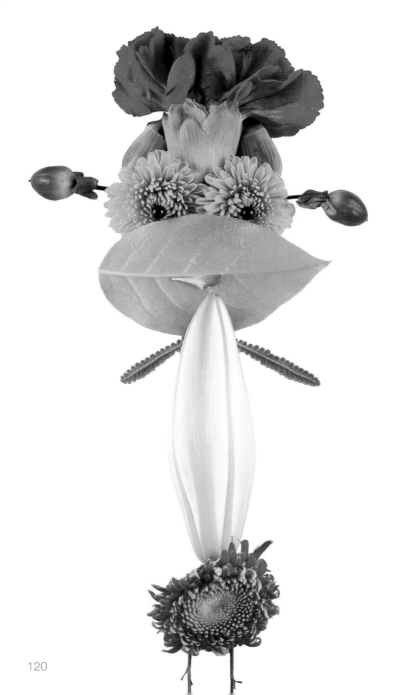

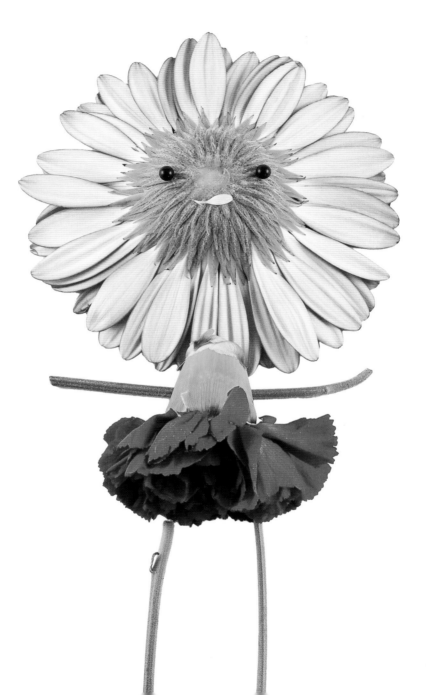

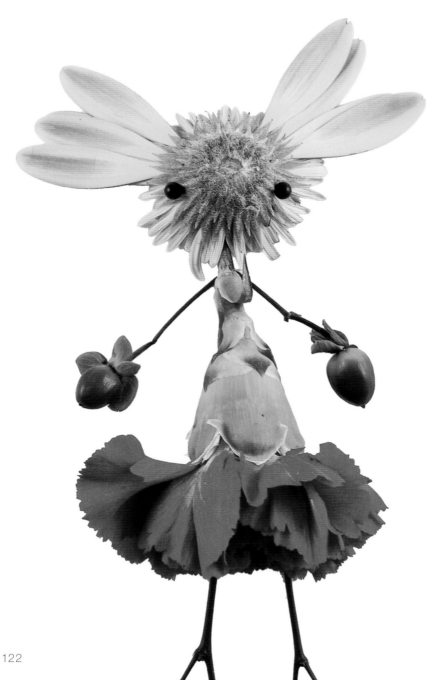

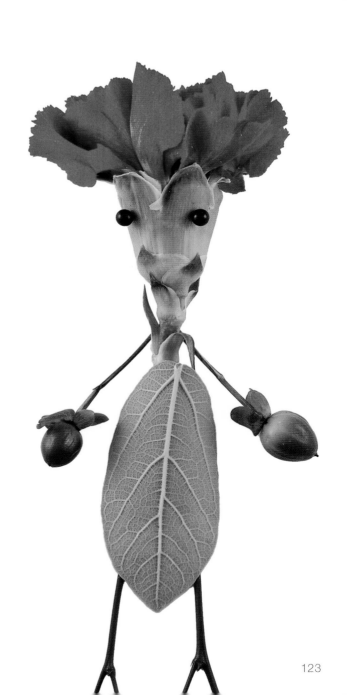

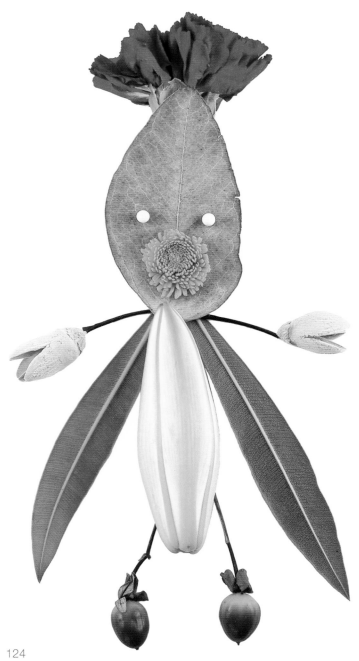

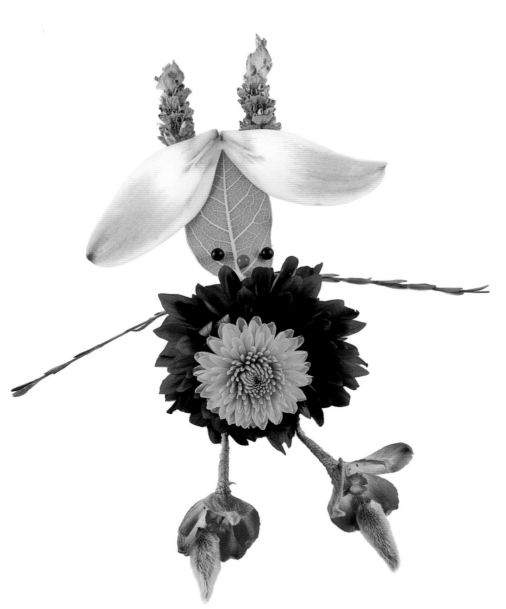

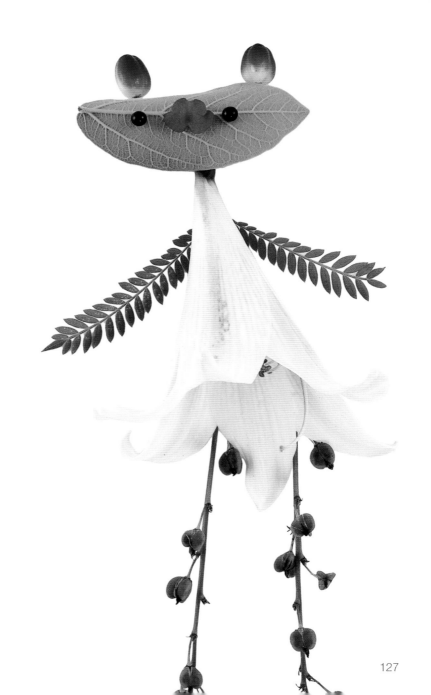

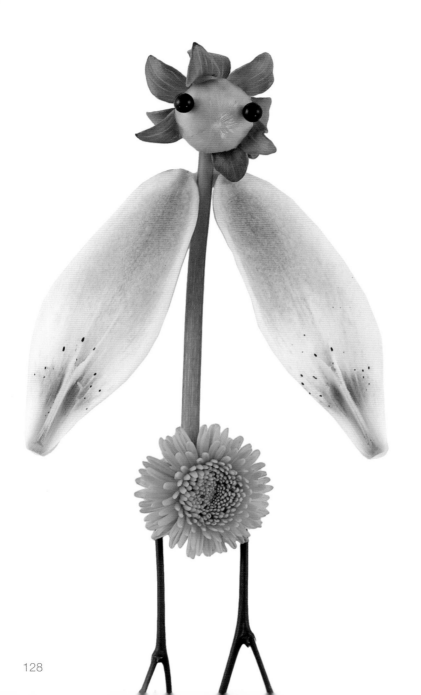

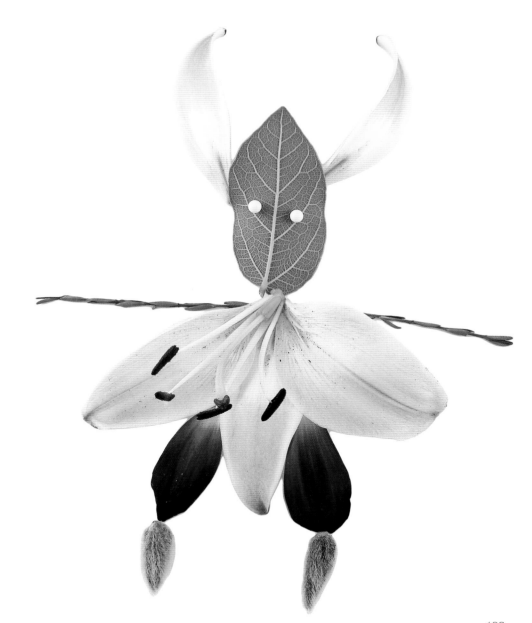

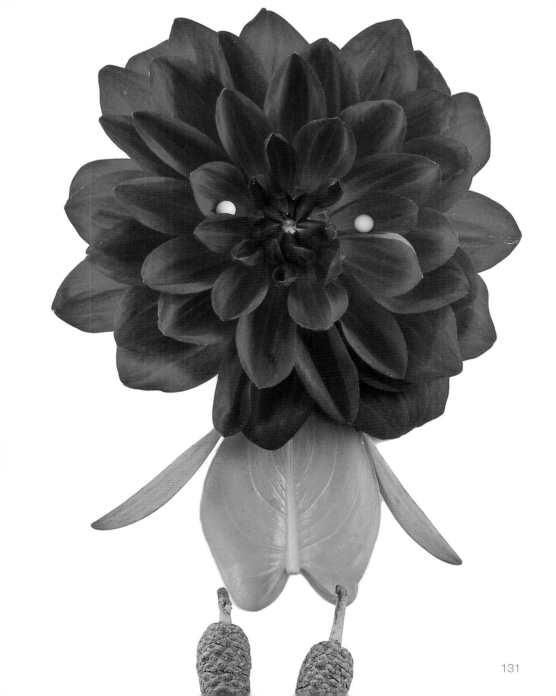

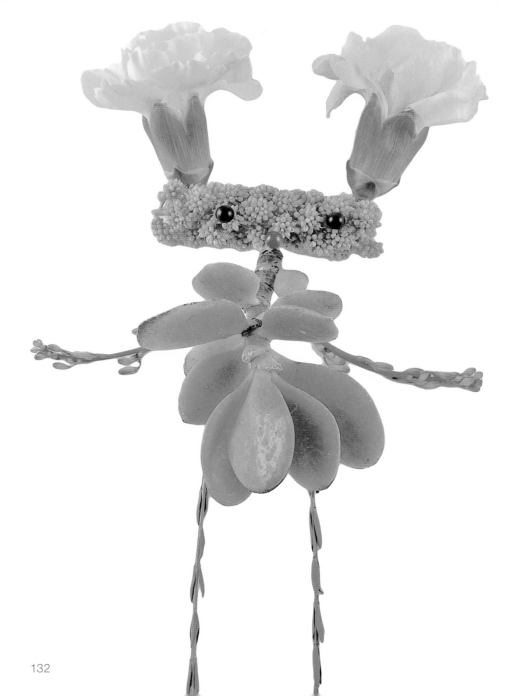

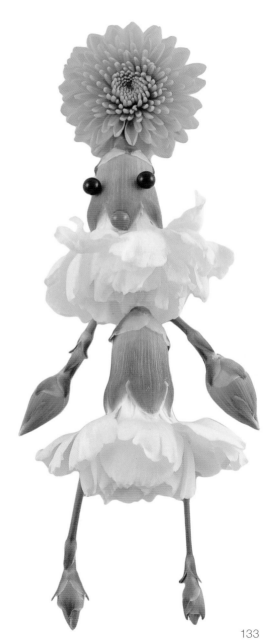

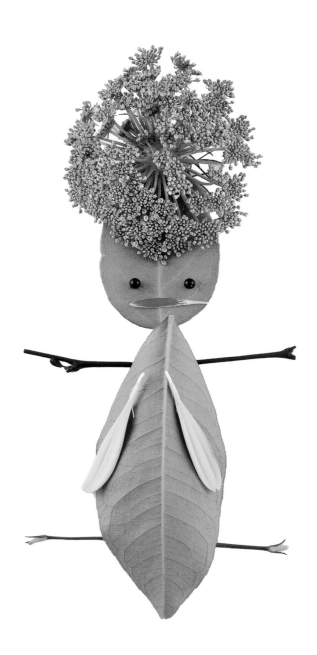

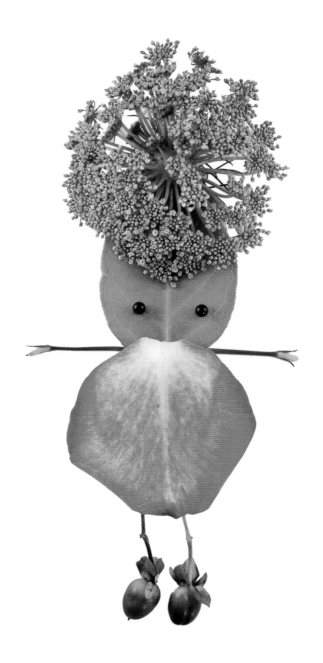

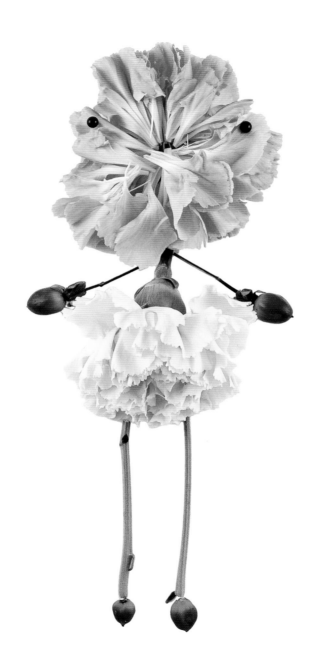

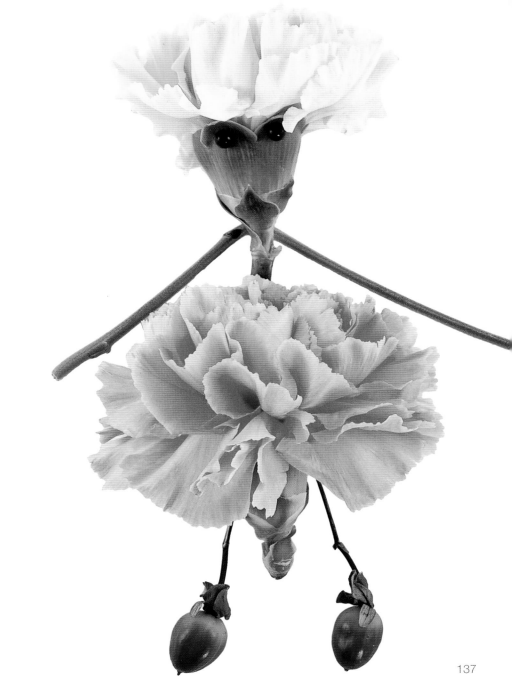

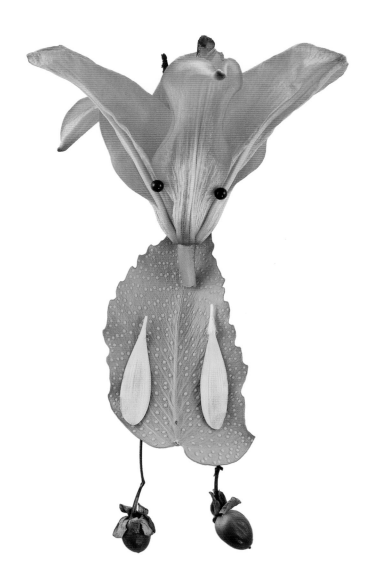

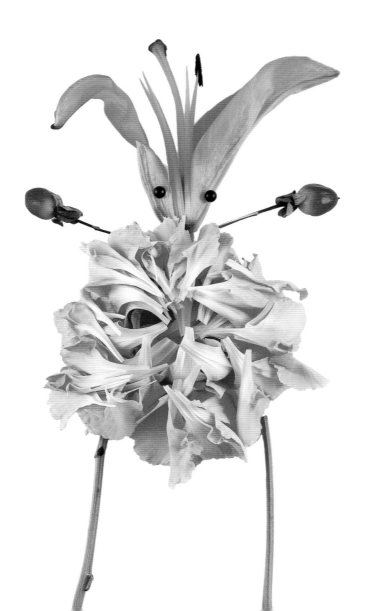

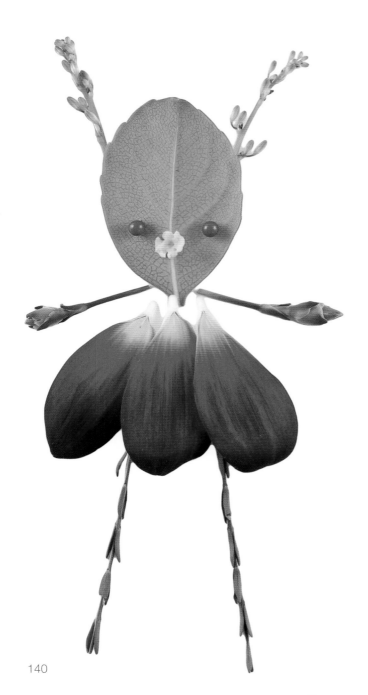

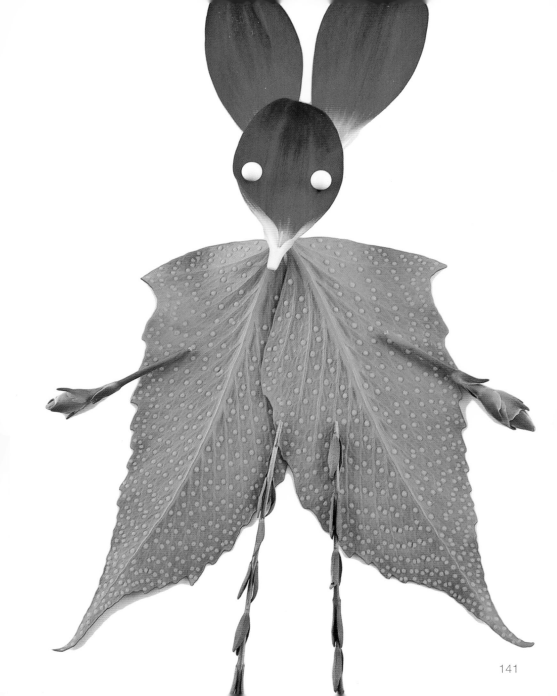

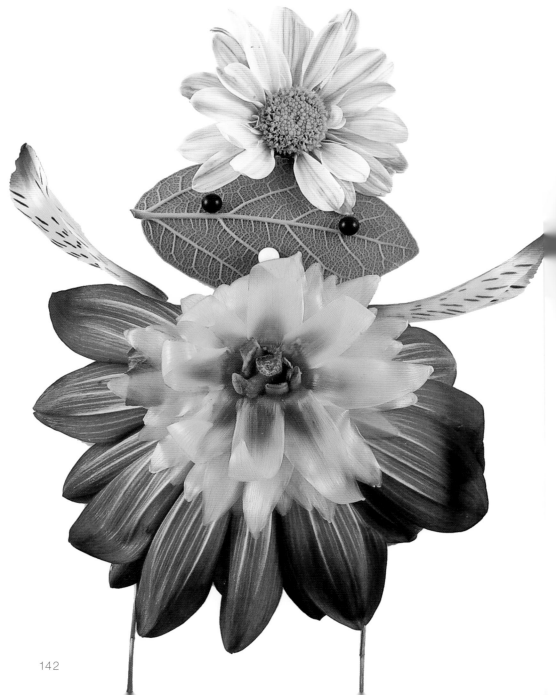

ELSA MORA

ELSA MORA is a multimedia artist born and raised on the island of Cuba. She has been showing her work at galleries and museums around the world since 1990. She met Bill Horberg, a film producer, in Havana in 2000 and they got married in 2002. Elsa and Bill currently live in Los Angeles, CA with their three children. From her studio she creates art and also runs a popular blog (www.elsita.typepad.com) where she writes about her creative life and family. Her son, who inspired this book, was diagnosed with autism in 2007 and he continues to be a source of wonder for her and the rest of the family.

ELSA MORA ist eine in Kuba geborene Multimedia-Künstlerin. Seit 1990 sind ihre Arbeiten in Galerien und Museen in aller Welt zu sehen. Im Jahr 2000 lernte sie in Havanna den Filmproduzenten Bill Horberg kennen, 2002 haben sie dann geheiratet. Derzeit leben Elsa und Bill mit ihren drei Kindern in Los Angeles. In ihrem Studio geht sie ihrer Kunst nach und schreibt dort auch ihren beliebten Blog (www.elsita.typepad.com), der ihrem Leben als Künstlerin und ihrer Familie gewidmet ist. Bei Ihrem Sohn, der ihr den Anstoß für dieses Buch gab, wurde 2007 Autismus diagnostiziert. Er ist für sie und den Rest der Familie weiterhin eine Inspiration.

ELSA MORA est une artiste multimédia qui est née et a grandi dans l'île de Cuba. Elle expose son œuvre dans les galeries et les musées du monde entier depuis 1990. Elle a rencontré Bill Horberg, un producteur de films, à la Havane en 2000 et ils se sont mariés en 2002. Elsa et Bill vivent maintenant à Los Angeles avec leurs trois enfants. C'est dans son stdio qu'elle crée son art et produit un blog très populaire (www.elsita.typepad.com) où elle décrit avec créativité sa vie et sa famille. En 2007 les médecins ont diagnostiqué que son fils qui a inspiré ce livre était autiste et il continue d'être une source d'émerveillement pour elle et toute sa famille.

© 2009 teNeues Verlag GmbH & Co. KG, Kempen
Photographs © 2009 Elsa Mora
All rights reserved.

Photographs by Elsa Mora
Photographic Retouching by Greg Irikura
Design by Allison Stern
Editorial Coordination by Maria Regina Madarang
Introduction by Elsa Mora
Translations by Carmen E. Berelson (German) and Helena Solodsky-Wang (French)

Published by teNeues Publishing Group

teNeues Verlag GmbH + Co. KG
Am Selder 37, 47906 Kempen, Germany
Phone: 0049-(0)2152-916-0, Fax: 0049-(0)2152-916-111
e-mail: books@teneues.de
Press department: Andrea Rehn
Phone: 0049-(0)2152-916-202
arehn@teneues.de

teNeues Publishing Company
16 West 22nd Street, New York, NY 10010, USA
Phone: 001-212-627-9090, Fax: 001-212-627-9511

teNeues Publishing UK Ltd.
York Villa, York Road, Byfleet, KT14 7HX, Great Britain
Phone: 0044-(0)1932-4035-09, Fax: 0044-(0)1932-4035-14

teNeues France S.A.R.L.
93, rue Bannier, 45000 Orléans, France
Phone: 0033-(0)2-3854-1071, Fax: 0033-(0)2-3862-5340

www.teneues.com

ISBN 978-3-8327-9313-5

Printed in China

Bibliographic information published by the Deutsche Nationalbibliothek. The Deutsche Nationalbibliothek lists
this publication in the Deutsche Nationalbibliografie; detailed bibliographic data are available in the Internet
at http://dnb.d-nb.de.

teNeues Publishing Group
Kempen
Düsseldorf
Hamburg
London
Munich
New York
Paris

teNeues

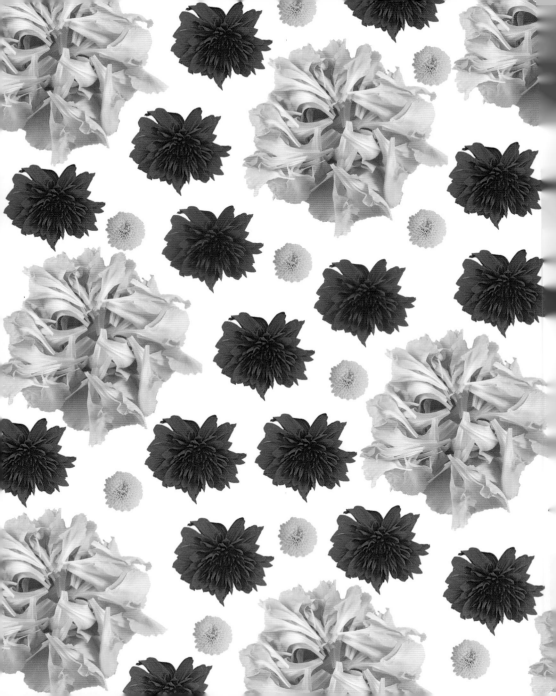